THE HAUNTED MID-SHORE

SPIRITS OF CAROLINE, DORCHESTER AND TALBOT COUNTIES

MINDIE BURGOYNE | Foreword by Ian Fleming

Published by Haunted America
A Division of The History Press
Charleston, SC 29403
www.historypress.net

Copyright © 2015 by Mindie Burgoyne
All rights reserved

Back cover, lower: *Courtesy of the Talbot County Free Library*.
Opposite: Mindie Burgoyne and grandson Tristan English.

Unless otherwise noted, all images were taken by the author.

First published 2015

Manufactured in the United States

ISBN 978.1.62619.813.5

Library of Congress Control Number: 2015941006

Notice: The information in this book is true and complete to the best of our knowledge. It is offered without guarantee on the part of the author or The History Press. The author and The History Press disclaim all liability in connection with the use of this book.

All rights reserved. No part of this book may be reproduced or transmitted in any form whatsoever without prior written permission from the publisher except in the case of brief quotations embodied in critical articles and reviews.

For Muffin Man
A bright little boy with a mind full of questions, a spirit full of joy and an endless hunger for scary stories.
I love you so.

CONTENTS

Foreword, by Ian Fleming 7
Acknowledgements 11
Introduction 15

I. CAROLINE COUNTY 19
1. The Town Dog Killer 21
2. My Time in the Denton Jail 26
3. The Underground Railroad at Linchester Mill 36
4. Cannon Hall and Maggie's Bridge 40

II. HIGH STREET IN CAMBRIDGE 49
5. The Crossroads of Judgment, Punishment and Redemption 53
6. Bloody Henny at Spring Valley 57
7. The Floating Ghost at the Oldest House in Cambridge 61
8. The LeCompte Curse 67
9. The Ghosts of the Leonard Hotel 70
10. The Man Who Was Buried with His Dog 74
11. A Banker's Unrestful Spirit 78
12. Tales of the Choptank River 82

III. LOWER DORCHESTER 85
13. Mary's Ghost at Old Salty's 87
14. The Seven Gates of Hell and the Lady with the Lamp 90

Contents

IV. EASTON AND SURROUNDS	93
15. The Colonel in the Courthouse	95
16. Are You There, Mr. Grymes?	99
17. Marguerite, the Murdered Actress	102
18. The Frenchman's Oak	106
19. The Witches of Plain Dealing	112
20. The Unionville Soldiers	116
V. ST. MICHAELS	119
21. The Spirits of Navy Point	121
22. Pennies from Heaven	124
23. The Kemp House and Robert E. Lee	127
VI. OXFORD	131
24. My Scary Night at the Robert Morris Inn	133
25. The Death Chant at Bachelor's Point	136
Afterword	137
Bibliography	139
About the Author	143

FOREWORD

I have been in the hospitality, leisure and tourism business for thirty-seven years, and I feel privileged. I love what I do, and I struggle to call it work. But the work has been good to me, and my passion for the hospitality industry has led me to manage and develop hotels, resorts and inns throughout the United Kingdom, United States and West Indies, from ancient small boutique inns to grand industry legends. And, in turn, I've felt the industry's appreciation and recognition over the years. At the age of thirty, I was honored with the UK hospitality industry's "30 Under 30 Acorn Award." In 2012, I received the "Entrepreneur Commendation Award" at the Scottish Hotel Awards, and I am a full member of the Institute of Hospitality.

Old castles turned hotels are not without their ghosts. My experiences with spirits and hauntings were as director of the twelfth-century Taunton Castle in Midhurst, Somerset, United Kingdom, now a fine hotel and museum. The Great Hall was once the scene of "the Bloody Assizes" of 1685 following the Battle of Sedgemoor. Infamous "Hanging Judge Jeffries" condemned two hundred men to the gallows and sentenced their women to be flogged. Those of us who have worked there ignore the echoes of the steady tramp of invisible boots, as unseen soldiers drag the hapless prisoners before the diabolical Jeffries.

I was general manager of fourteenth-century Spread Eagle Inn in Midhurst, where the main body of the ancient inn hosts a paneled bedroom with priest hole behind a chimney where houseguests hid during the civil war. It has a fascinating history that includes tales of smugglers' hideaways,

Foreword

royal visits and the ghost of the Golden Lady. Here, too, those of us who worked there would ignore the sounds of footsteps in rooms we well knew were not occupied.

Today, as part owner of the 1710 Robert Morris Inn on the Mid-Shore in Oxford, Maryland, I see a similarly rich history. The inn has given service to many generations as hostelry, soldiers' convalescence home and much more. Many souls have passed here, including that of Robert Morris Sr., who died three days after receiving a wound from a ship's gun salute in his honor. Late at night, we ignore the creaks and murmurs of a timber building bending in the wind, when in fact there is none; the cold breeze on the back of neck at the height of the summer; and the matching accounts of fleeing terrified guests over five years, each having occupied two specific rooms in the inn.

My family and I fell in love with the Eastern Shore back in the late 1980s while I was managing and developing the Inn at Perry Cabin in St. Michaels. What attracts droves of seasonal tourists is the glorious Chesapeake Bay and its tributaries for sailing, canoeing, kayaking and crabbing, plus wonderful golf courses, shooting and horse riding and perfectly manicured colonial towns charming and rich in history, antique stores and great restaurants. The renowned Eastern Shore is a popular destination for watching eagles soar and enjoying a sporting life full of stunning sunsets and tranquility. But once you know the area and set out to explore its lesser-known highways and byways, the towns and villages, you discover so much more. Historic homes abound, little touched, little known and many with rich and interesting stories. Many of these homes and towns have history reluctantly unearthed, reflecting the turbulent history of the area and practices and events many would rather forget. It's all fascinating stuff.

I met Mindie Burgoyne when we first acquired the Robert Morris Inn five years ago. She was our point of contact for Maryland's Department of Business and Economic Development. Her territory is far reaching, with five large counties, including three in the Mid-Shore region, but she proved to be a phenomenal source of knowledge and information that went far beyond her remit. After ten years of working with all of the towns and the counties on the Eastern Shore through her day job, Mindie has developed a strong sense of the historic and tourism assets in the region and developed an audience through blogging and social media. Mindie has also built a company that provides ghost walks on the Mid-Shore, and this book will be an added support to the tourists and locals who enjoy the walks, plus an opportunity for those who can't do the walks to still enjoy the stories and history. This indispensable haunting history book will entertain enormously,

Foreword

inform and become a key part of your travel library. Folklorists will enjoy Mindie's unique look at the variations between paranormal phenomenon as well as her unique writing style.

So, dear reader, we do want to believe. Not only does proof positive give us a confirmation of life after death, but it also affirms the deep faith we have in the power of the soul. None of us want to believe that this is all there is.

—Ian Fleming

Member of the Talbot County Tourism Board and owner of the Robert Morris Inn in Oxford, Maryland, and the Lake of Menteith Hotel, Scotland

ACKNOWLEDGEMENTS

Who reads the acknowledgements in a book? I know people normally skip over this section, but I hope you will take the time to read through this little commentary because I will be naming some of the best storytellers on the Eastern Shore. What a privilege it is for me to be able to collect stories and retell them. That's what this book is about. And I hope, in turn, that you will retell the stories I share here.

The storytellers named here not only shared stories, but they also shared a connection, a love of the landscape and the heritage, a love of Eastern Shore people. There is a magic that happens when storytellers get together. A memory is created. And there, inside that memory, is a bond that lives after the stories are told. I am overwhelmed with gratitude for these people, the stories, the memories and the friendship.

The most prolific storyteller I know is J.O.K. Walsh. Every conversation is a story, and this is why I love spending time with J.O.K. I thank him for explaining how the "crossings" worked in the Underground Railroad and why the crossing at Hunting Creek behind Linchester Mill was so important. I thank J.O.K. also for introducing me to Sophie Kerr and her stories about the Eastern Shore and also for tipping me off about Kerr's dog killer story being linked to a character in Denton.

I send special thanks to Charles Andrew for sharing his stories about his time as warden at the Caroline jail and for connecting me with his late father, Sheriff Andrew. I offer sincere thanks to Charles Moore, patriarch of the Moore Funeral Home in Denton, for a one-hour reminiscence of

Acknowledgements

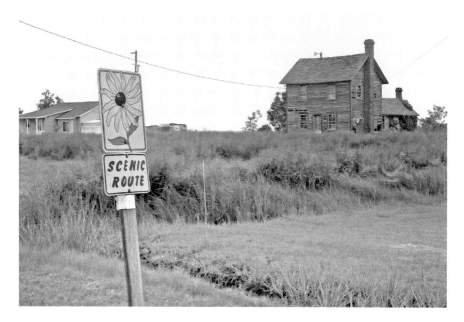

Road sign marking a Maryland Scenic Byway on Hoopers Island, Dorchester County.

Denton's crazy characters, heroes and most amazing people. I will never forget his response when I asked, "What is the saddest story you know?" He thought and then, with tears coming into his eyes, said, "The children. All of the children I had to take of. You can never say goodbye to a child."

I extend the warmest appreciation to Warden Ruth Coulbourne and her amazing staff for their stories of Wish Sheppard, to Sara Visintainer for connecting us and a special thank-you to Jeff Porter and Ron Orendorf, who escorted me on a storytelling walk that made Wish Sheppard more than just a character in a ghost story.

I am deeply grateful to Marilyn Griffies of Woodland for telling me about her beloved Cannon Hall so shortly after losing it to a devastating October fire. I so hope you are well, Marilyn, and settled in someplace wonderful. And without my favorite Eastern Shore storyteller, Hal Roth, I would have never known about Maggie's Bridge or that I can't ever get to Puckam. I thank Helen Chappelle not only for her friendship and support but also for so much history on Eastern Shore death rituals. The *Chesapeake Book of the Dead* is a treasure. I thank Jim and Marianne Benson, innkeepers at the Cambridge House, for revealing the Laird Henry House stories, and thanks to the Richardson Maritime Museum volunteers and staff for sharing the

Acknowledgements

stories of their haunted museum. Thank you to Jay Newcomb and the staff from Old Salty's for telling us about Mary's Ghost and all the spirits that haunt that fabulous restaurant. And a sincere thanks to Mary Handley for helping me understand how roads get named "High Street" and how to properly say "LeCompte" when I'm in Dorchester County.

I am so thankful to Ian Fleming for writing the foreword to this book and for his hospitality at the Robert Morris Inn, as well as his ghost stories of Scotland and of the lady who fled the Robert Morris Inn after staying in room 1. My appreciation is heartfelt to Will Howard and John General for their stories about the Avalon Theater and Marguerite. What tremendous gifts you both have brought to the Talbot community. I am grateful to Debbi Dodson, the former Talbot County tourism director, who not only connected me to many good storytellers in Talbot County but also shared her story about the Colonel in the Courthouse. My sincerest thanks go to Chuck Eser and the folks at Calhoun MEBA School of Engineering for relating all of the history about Perry Hall and giving me a most excellent tour of the house and grounds. And thank you to Aida Trissell for welcoming us into the Victoriana Inn in St. Michaels and sharing the pennies from heaven story.

Much appreciation also goes to Hannah Cassilly and all the folks at The History Press. Hannah believed in this project from the beginning and has been so supportive of it. I will be forever thankful to Dr. Ray Thompson of Salisbury University and the Edward H. Nabb Research Center. Without his leadership and vision, so many Eastern Shore stories would be lost. And a warm thank-you to our ghost walk guides Missy Corley and Jen Fanning who tell most of these stories to hundreds of guests each year on our Cambridge, St. Michaels, Easton and Denton ghost walks. I wish to thank my daughter Lara for answering the ghost phone and keeping the customers happy and our other guides Maria Pippen, Kelly Craven, Alison Mickels and Christopher Wright for their encouragement and service. And a huge thank-you to the folks at the Talbot County Free Library, the Caroline Library in Denton and the Dorchester Library in Cambridge. Your assistance has a huge impact on the community, and it is always a pleasure to be in your libraries. And I would be remiss if I didn't thank all of our ghost tour patrons and Facebook fans. You have provided details, corrected misinformation, given clarity to confusion and been the best listening ears anyone could hope for. Without you, this would be a very uninteresting book.

And finally—my most important expression of thanks—without the continual support of my loving husband, Dan Burgoyne, I could never put fingers to the keyboard. I would be spinning out of control, trying

Acknowledgements

to do everything and accomplishing nothing. Thank you, my darling, for being there—for always being there—to support me, encourage me, compliment me and chastise me (OK, that rarely works) and for being my anchor and my soul friend. Without you, I could not write. Without you, I would not write.

INTRODUCTION

Nothing is unimportant that belongs to the past; to the student of history, whether it be the grand epics of nations, or the simple story of a county or neighborhood, nothing is valueless that is illustrative of the varying conditions of society.
—*Colonel Oswald Tilghman*

The first Eastern Shore ghost story I ever heard was the story of Big Lizz, the African slave who was beheaded by her master just after she followed orders to bury his money. I heard the story on a bus ride through the marshes of lower Dorchester County. The bus driver, who was silent until we drove into the marsh, began the story as most of us were dozing off after a long day of touring seafood-processing plants. After he finished the story, he never said another word. It was a completely silent thirty-minute ride back to Cambridge. It was strange that he was only motivated to break his silence to tell us about Big Lizz. So after everyone exited the bus, I asked him why he told that particular story. He said that most people like to hear it. "You always tell the story of Big Lizz when you're driving near Greenbriar Swamp," he said. "It's the natural thing to do."

Perhaps bus drivers feel compelled to reverence the old spirits by telling their stories: a gesture of respect in hopes that the spirits will leave them alone. I've remembered that day often and have heard the Big Lizz story, which is featured in my book *Haunted Eastern Shore*, over and over. It seems that the story is married to the land. And through reading and listening, I've discovered many more stories linked to the land—some so deeply

Introduction

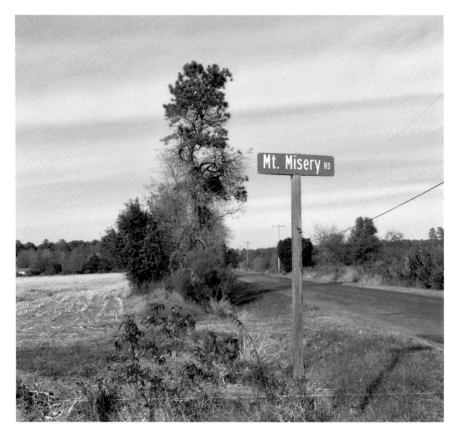

Mt. Misery Road in Talbot County.

intertwined that the place becomes branded by spirit who haunts it, and the locals accept them as one.

Nine of Maryland's twenty-three counties are east of the Chesapeake Bay. And though these nine Eastern Shore counties compose one third of Maryland's landmass, they hold only 7 percent of its population. The middle three Eastern Shore counties—Caroline, Dorchester and Talbot— have only 22 percent of the Eastern Shore's population and only 1.7 percent of Maryland's population. It is the state's most undeveloped, uninhabited tri-county region.

The wide-open spaces of the Mid-Shore have changed little in the last three hundred years. Though the traffic through Cambridge, Easton and Denton would have a visitor thinking the region was overdeveloped, the same visitor would only have to traverse the back roads to see how open

Introduction

and unpopulated the land actually is. Places far removed like Blackwater, Tilghman Island and Bishops Head leave first-time visitors wondering if they're still in Maryland.

Maybe it's the vastness of the open land that keeps the spirits right at the edge of perception. There's so much space. When the landscape is uninterrupted by development, our senses are keener. Our psychic abilities are magnified. The spirits are always with us no matter where we are, but on the Mid-Shore, it's easier to cross into their world and they into ours because there are so few distractions, and the landscape has barely changed.

The open spaces are indeed beautiful, sometimes breathtaking. But they also leave a sense of isolation. Without the distraction of worldly things, the "otherworld" becomes uncomfortably near. That moment when the traveler feels an overwhelming sense of "aloneness" is when the old memories start to creep out of the land. The haunted past spreads across the fields like thick mist, and suddenly two worlds become one. Signs and omens appear: a bald eagle circles above, a deer races across a field, a great blue heron ascends over the marsh and all of the trees seem to have faces. The haunted landscape feeds the imagination, and if one is prone to listen, the spirits will speak.

It might be the anguished cry of a young girl coming from an attic room, or a vision of the lady in white wandering with her lantern near the Seven Gates of Hell or the long-dead Mr. Grymes tugging at the pant leg of a hotel employee who has dozed off in the lobby of the Tidewater Inn. It might be the muffled sound of the death chant sung by the Indians at Bachelor Point who strode arm-in-arm into the Choptank River in a mass suicide. It may be old Wish Sheppard, the last man to be executed in Caroline County, turning on the attic light in the Denton jail. And for those bold enough to walk past the Dorchester Courthouse between midnight and 1:00 a.m. (the witching hour), it might be the chilling, child-like whisper asking, "What were you hung for, Bloody Henny?" along with the rubbing and creaking of rope against branch—the branch that supported the dangling dead body of Henny Insley, an enslaved woman who hacked her pregnant mistress to death.

All of these stories are retold in this book, as are the stories of Marguerite, the murdered vaudeville actress who was dumped in the Avalon Theater elevator, the decapitated Maggie Bloxom coming out of the woods at Maggie's Bridge and the lovers who hid in the Frenchman's Oak. There are stories of sea captains and governors, soldiers and farmers, witches and

Introduction

ladies of the evening, and all of them once lived (and still live) somewhere on the Mid-Shore.

It's a magical place and an eerie place, as rich in folklore and legends as it is in natural resources and generations of people tied to the land and water. These combined elements—place, story, landscape and characters—give us the setting for this book. Feel free to take it along with you as you explore the back roads of the Mid-Shore. But beware: the spirits prey on the traveler just as they prey on the non-believer. It's always these who have the most terrifying experiences. My hope is that you will enjoy the stories, explore the land, respect the spirits and be as enchanted as I am by this mystical region.

Part I
Caroline County

Caroline County is the only county on the Eastern Shore that is landlocked. With the State of Delaware on one side and the counties that border the Chesapeake Bay on the other, Caroline is the only county of the thirteen on Delmarva that touches neither the Atlantic Ocean nor the Chesapeake Bay. It has some beautiful waterways in the Choptank River, Tuckahoe Creek and the Marshyhope. But it is far richer in farmland, and within Caroline's landscape rests the agricultural imagination of the Eastern Shore. It is possible to grow almost anything in Caroline. Where most of the Delmarva Peninsula focuses on poultry houses and grain, Caroline reaches past that and adds alpaca and bison farms, dairies and vineyards, orchards

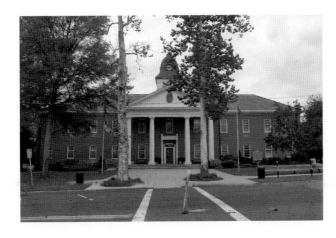

Caroline County Courthouse in Denton.

and flower growers. It once attracted people from all over the mid-Atlantic region with newspaper advertisements naming Caroline County as the "Garden of America."

But Caroline has its ghosts and haunted places. It claims one of the most haunted sites in all of Maryland: the Denton jail, haunted by the spirit of Wish Sheppard. The courthouse green in Denton has been the scene of three brutal lynchings and dismemberments. And Caroline also is home to many spirits of the Underground Railroad, spirits who were at the threshold of freedom when they made the crossing at Hunting Creek near Linchester Mill, and the woods behind the mill, just like the courthouse green and the jail, vibrate with a distant energy.

CHAPTER 1

The Town Dog Killer

The most beautiful house on Caroline County's Courthouse Square in Denton sits on the corner of Gay and Second Streets. It's a Second Empire Victorian style, and its hipped roof, center cupola, iron fence and ornate trim set it apart from every other house on the square. The ample corner lot runs straight down to the Choptank River, which is wide and placid at this northern end, some thirty-plus miles from where it empties into the Chesapeake Bay.

The house has been beautifully restored to look almost exactly as it did when it was built 130 years ago. But this beautiful jewel in Denton's historic district has been a sad house. In the last 15 years, it's changed owners four times and remained vacant for much of that time.

When a longtime owner of the property moved out in 2000, a real estate agent showed the property to a potential buyer who lived out of state. The owner wasn't present during the viewing, and the potential buyers took several photographs of the house. About a month after they had looked at the house, they returned to Denton hoping to find the owner. When they knocked on the door, there was no answer, so they visited the town hall hoping to get help with locating the owner.

These potential buyers had decided not to buy the house. But when they reviewed the photographs they had taken, they noticed a strange anomaly in one of them. It was disturbing. It was a view of the house from the outside that showed the front with all of its beautiful features and ornate trim. But it also showed the image of a child looking out of the third-floor

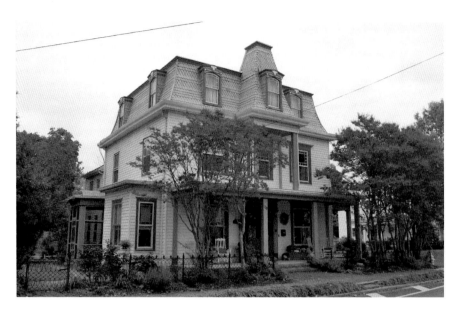

Taylor House on the Courthouse Square in Denton.

window. The owner wasn't present when the couple viewed the house, and they'd been told that no children lived there. The couple had also gone through that third floor, and they saw no sign of a child—no toys, no clothes, nothing to indicate that a child even lived in the house. So naturally, the image of a child in that window caught them by surprise. The couple also observed that in their photograph, the child appeared to be a little girl dressed in old-time white clothing and wearing a large bonnet. They felt compelled to tell the owner. They wondered if a child spirit was trying to send a message. They drove to Denton with the picture in hand with the intent of showing it to the owner and seeing if the owner knew about the child or had experienced any kind of unexplained events. They wondered if a child might have died in the house.

When the couple arrived in Denton, they knocked on the front door, but there was no answer. So they went to the town hall to see if anyone there knew about the history of the house or could offer insight about the child in the window. The Denton town manager met with them and saw the picture, but neither she nor her staff could help with linking the history of the house to the child. People in Denton knew it as the Taylor House, named for a previous owner, but there was no memory of a small child living there. So for that couple, the visit to Denton was a dead end. As far as anyone knows,

they never connected with the owner or returned to Denton. The child in the window remained a mystery.

This house does have a sad history. Denton residents in their eighties and nineties can recall the house being owned by a retired farmer named Will Taylor. He was commonly referred to as "Old Man Taylor" and was suspected of poisoning the neighborhood dogs. Marianne Walsh recalled that when she was a little girl, her mother and her mother's friends often talked about one Sunday morning when Denton families woke up to find their dogs dead in their yards, in the roadways and even a few dead on the courthouse green. They'd been poisoned, and everyone suspected "Old Man Taylor" because he was always threatening to do something about dogs that got into his yard or walked too close to his fence. According to his neighbors, he liked the boundary his fence offered between him and the rest of the world. The whole property had a kind of bad karma or negative energy when the Taylors owned it.

Sophie Kerr was a Denton native, and she became a successful magazine editor and novelist in the early 1900s. Though she left Denton and moved to New York to work as a journalist, gaining notoriety writing for publications such as the *Saturday Evening Post* and *McCalls Magazine*, she never forgot her childhood home, and she returned often. She was born and grew up in a Denton farmhouse about time that the Taylor House was first built. Both her house and the Taylor House still stand a mere mile apart. Sophie would have known the Taylors and would have been in the thick of all the banter and drama that went on between neighbors. She set many of her short stories and novels in landscapes and communities that had a startling similarity to Caroline County—and Denton in particular.

In her short story "Peace is Wonderful," which is included in her book *Sounds of Petticoats and Other Stories of the Eastern Shore*, Sophie Kerr tells the story of a grumpy old farmer who retires and moves into the center of a rural town. He purchases "Emerson House," the nicest house on the street. Kerr writes, "Charlie went round the Square to pass the Emerson house, a high-shouldered building with a cupola, set back in a good-sized yard enclosed by an iron fence."

The story depicts the grumpy old farmer who is not able to get along with his neighbors, and he hates dogs. He is suspected of poisoning the town's dogs toward the end of the story. It's quite a parallel to the real-life Taylor story in Denton. Both houses are set on a courthouse square. Both houses have a shouldered roof, cupola and iron fence. Both houses are owned by an antisocial retired farmer who has a propensity for dog poisoning. But if these

similarities weren't enough to indicate Sophie Kerr was retelling the Taylor story in Denton, the farmer in Sophie's story is named is Louis Rolyat.

Rolyat is Taylor spelled backward.

In her story, Sophie Kerr depicts the Taylor House (or Emerson House, as she named it) as a dark place, with no love and no light. Mr. Rolyat forces his wife to keep the shutters closed so no one can spy on them. It's a house that causes people wonder what really goes on inside. Rolyat berates his wife and daughter, and they fear him. The neighbors try to be friendly, to reach out and to include the family in community gatherings, and they are repaid by having their dogs poisoned. The story does have a happy ending in that Mr. Rolyat gets hauled off to court and presumably jail for poisoning the dogs, and his wife and daughter are set free from their oppressor with a kinder future ahead.

Sophie Kerr knew the people in Denton at that time, and it's likely that she knew or at least had seen Will Taylor during her return trips home. Historians and Eastern Shore literary scholars say that Sophie Kerr based many of her stories on Caroline County and people that she knew. Her interpretation of Mr. Rolyat matches Walsh's recollections of Taylor, but Will Taylor died in 1930, so most everyone who knew him has passed on by now and can't weigh in on the comparison.

When we consider that the Taylor House might be haunted by the spirit of a child, Sophie Kerr's story is no help in trying to figure out who the child might be. The Rolyats have just one daughter, and she gets engaged at the end of the story.

What we do know is that William Taylor was a wealthy farmer, who was born in Delaware. He married Mollie Hignutt, a girl from Caroline County, and they settled on a farm in Hillsboro. They had three children. Their eldest was a son, W. Price Taylor, who was born around 1882, a year after they were married. They had a daughter, Miriam, five years later in 1887, and their youngest child, Katherine, was born in 1895. Somewhere between 1900 and 1910, the family moved into the Denton house. Price Taylor died in 1906 at age twenty-four, and if he lived in the Denton house, it was as an adult and for only a few years. Miriam got married but then divorced and returned to the Denton house, where she lived with her sister Katherine, who didn't marry until she was fifty. The two sisters lived in the Taylor House as single women up until 1945, when they sold the house shortly after their mother died. Neither daughter had any children. Or did they?

I interviewed Mr. Charlie Moore, whose family has owned the funeral home in Denton for over one hundred years. Mr. Moore, now in his nineties,

remembered Will Taylor well and recalled that he wasn't friendly. Mr. Moore also mentioned that Taylor had two daughters. Neither was married, but one of the daughters had a baby, a little girl. According to Mr. Moore, the child died when she was very little, before she was old enough to go to school. The Moores handled the funeral arrangements. Mr. Moore said the child's mother was never happy after the death and remained reclusive.

We don't know who haunts the Taylor House, and we never will. But Mr. Moore's commentary was a big surprise. And it is true that human emotion can burn an impression into an energy field, causing the energy of a place to take on the feelings. This is why some places feel sad or dangerous or peaceful or happy. One person in a place exhibiting a certain emotion can impact an energy field, but two people exhibiting the same emotion yields double the impact. So a family in sadness or grief in one place over many years can certainly shift an entire field to reflect their emotions, and the energy stays the same until something changes it. And there are countless cases of believed hauntings around people have been grieving loved ones for a long time. It's almost as if they will the spirit to return to them. Whether this is the case with the child in the window at the Taylor House, we can't say. But we can surmise that there was a lot of pain in that family: a harsh, unyielding patriarch; the death of an only son; two lonely daughters who never found the joy of raising families of their own. Maybe that sadness has lingered. Perhaps that heavy aura in the house has driven people away, and that's why no one has stayed very long.

But there is good news. The house is bright once again and full of hope. A couple has purchased it and are excited about making a few restorations and opening it up to the public as a bed-and-breakfast. They have acknowledged the story of a child spirit but have made no public comment. Perhaps the peace and happiness they radiate along with that of their of guests will reform the house's sad past and refocus the energy. And then perhaps the spirit of the little girl in the window can follow her own path into the next realm.

CHAPTER 2

MY TIME IN THE DENTON JAIL

The Denton Jail in Caroline County is one of the most haunted sites on the Eastern Shore. For nearly one hundred years, both staff and inmates have recounted stories of phantom shadows, footsteps, banging doors, voices and a handprint that couldn't be washed away, painted over or even covered up with concrete. The site is still active today. Over a dozen staff members, including the warden, show calm acceptance of the spirit that makes himself home at the jail and is not hesitant about making his presence known. He is comfortable there and moves freely about in a place where every hall, doorway and room is securely locked and rigged with cameras and alarms. They don't slow down his movements. He's at home in the jail. And why shouldn't he be? He's been living there since 1915. The jail staff even has a nickname for him. It's "Shep."

This jail was built in 1906. It sits on a corner of the Courthouse Square in downtown Denton between the courthouse green and the Choptank River. The old part of the building looks a little like a house with a front door and porch. It was a house of sorts when it was first built because the sheriff lived there with his family. They lived on the first floor, with the sheriff's wife tending to the domestic needs of the prisoners, and the inmates were housed in other parts of the building. Today, that old entrance is not the main entrance anymore, and the building has undergone several expansions and renovations. It serves as the Caroline County Correctional Facility and houses up to 125 inmates.

Caroline County

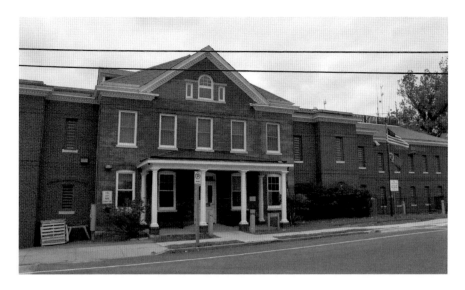

The Caroline County Jail is one of the most haunted sites on the Eastern Shore.

I wrote about this jail and its resident ghost, Aloysius "Wish" Sheppard, in my book *Haunted Eastern Shore*, and the Wish Sheppard story is still one of the most famous on the Eastern Shore. This jail is also a stop on our ghost walks, and it's almost inevitable that someone on the Denton walk currently works in the jail, has worked in the jail or knows someone who works in the jail—and they have a story about Wish. It is one of the most talked about haunted places. I always wanted to see the inside, especially the old part—the part that was the original jail where Wish Sheppard would have been hanged. I made an inquiry about getting a tour to continue my historical and haunted research regarding the jail, and the warden cleared me for a personal tour. She also made staff available for interviews. The focus of the interviews was the ghost of Wish Sheppard and how he manifests himself in the jail.

Wish Sheppard was executed on August 26, 1915. It was one of two legal executions in Caroline County, the first being Shelby Jump, a white farmer who shot his brother Peter in 1829. Wish was a nineteen-year-old African American from Federalsburg when he was charged with raping a fourteen-year-old Caucasian girl named Mildred Clark. He was convicted and sentenced to death by hanging. The sentence was carried out behind the jail on the grounds that border the Choptank River.

Wish had been in trouble before. In 1912, he was in court for stealing five cents and was found guilty. In 1913, he was caught stealing a bike and

fifteen dollars, and he went to jail for eighteen months. It was just shortly after returning home from that stay that he was arrested again. When the investigation for the rape of Mildred Clark began, the sheriff went to Wish Sheppard's home and told Mrs. Sheppard that he wanted to ask Wish some questions. When Mrs. Sheppard saw her son, she told Wish that the sheriff wanted to talk to him, and Wish sought out the sheriff to see what he wanted. That was the last time Mrs. Sheppard saw her boy alive. He was quickly charged with the sexual assault of a white female, and he offered a confession. He later said that the confession was forced because he was told an angry mob would likely lynch him if he didn't confess. This was a time when lynchings were common, so Wish certainly had something to fear with that threat. When Mrs. Sheppard was told about the charges, she said that people must have misunderstood. Wish was friends with Mildred. They spent time together. Wish recanted his confession but also waived his right to a jury trial because it was likely that a mob mentality would rule there as well. So a judge heard the case. He found Wish guilty and sentenced him to hang.

Most everyone who saw Wish after his sentencing said that he was calm and shy and evidently accepting of his terrible fate. A few children who saw him through the jailhouse window while they were observing the gallows being erected said that they talked to him. Allee Allaband, who was born in Tuckahoe Neck, recounted the conversation he had as a child with Wish Sheppard.

He said, "I talked to Wish Sheppard the afternoon before he had his last supper…Wish had to know what they were constructing because of the people going up and down the hill, but he didn't seem impressed. Think he had reconciled himself to the fact he was going to be hanged."

The *Denton Journal* reported on August 28, 1915, that on the night before his death, Wish was attended by two black preachers, Reverend J.H. Fitchett and Reverend F.T. Johnson, and four black women. Holding religious services in his cell, they sang and prayed for Wish. The chorus was heard as it floated across the Choptank River as far as a mile away. The newspapers reported that hundreds were gathered to watch the execution.

Caroline County sheriff James Temple tried to play down the spectacle by obstructing the public view of the execution with wooden fencing. But people eager to watch positioned themselves on balconies or got in boats and watched from the Choptank River. One Baltimore photographer came down to shoot pictures of the execution, which he later turned into commemorative postcards.

Eyewitnesses quoted in *Voices of the Land: A Caroline County Memoir* state that Sheriff Temple couldn't bring himself to put his hand on the lever that dropped the floor of the gallows. Typically there were four officials on the gallows who would stack their hands on the lever and push at the same time so that no single person would have to bear the responsibility for carrying out the death sentence. But the sheriff lost his nerve. An eyewitness said he didn't appear willing to do it.

After her son's death, Mrs. Sheppard received her boy's body in secret so that she wouldn't be assaulted or the grave desecrated. Wish was placed in an unmarked grave, and the location has long been forgotten. After Wish was hanged, a handprint appeared on the wall next to the steel door of his cell. Some said that Wish gripped the doorway when he resisted being taken to the gallows. This is unlikely because he displayed no other agitated behavior prior to being hanged, and there were many eyewitnesses who said as much.

The handprint never faded and couldn't be removed. Sheriff Temple tried to paint over it, but the print gradually wore through. The next sheriff, Sheriff William Andrews, also tried to paint over it and even added plaster. But the handprint eventually bled through again. Sheriff Louis Andrews succeeded his father, William, as sheriff, and he smeared concrete over the print, but it still bled through. The steel door adjacent to the wall never worked properly, according to Sheriff Louis Andrews. Sometimes it wouldn't stay locked, and other times it wouldn't open. Finally, the jail stopped housing prisoners in there.

In the 1980s, the jail was expanded and renovated. The door and wall with the handprint were not removed; they were simply covered with a new wall. Today, that covered wall is behind a wall in the commercial kitchen. When the kitchen was being remodeled a few years back, they tore some walls out and discovered another wall directly behind one of the walls they demolished. The older wall included a jail cell door. Everyone stood in silence. They knew immediately that this was the entrance to Wish Sheppard's cell that had been built over many years before. Unfortunately, the handprint was on the opposite side of this "wall-behind-the wall" and was inaccessible. Just like in the old days, the steel door wouldn't open. One worker even tried to put a mirror through the window in the cell door to see if he could catch a glimpse of the handprint. But it was too dark, and there wasn't enough space to maneuver the mirror. They photographed the door and then continued with the renovations and once again covered up the old wall with the door and handprint.

The Haunted Mid-Shore

According to Sheriff Andrews, the inmates at the Denton jail were tormented by Wish. They'd see him in the hallways, they'd hear him climbing the stairs and they were attacked in their cells and showed scratches and gash marks. A couple of them said Wish grabbed their watches and took them, and sure enough, those inmates were covered with scratches and the watches showed up broken outside the jail yard, beyond the inmate boundaries. The sheriff reported that the inmates were often terrified and would call out to him in the night. And he'd come with his lantern (and later a flashlight) and point out that there was nothing there to be afraid of.

The sheriff even recounted the story about a famous female inmate named Annie Thomas who was charged with murder. She was on the second level of the jail and chastised the sheriff one morning for trying to scare her in the middle of the night. She asked him, "Why'd you try to scare me last night, dragging those chains up and down those metal steps?"

In the late 1990s, the jail underwent another expansion, and the 911 call center was moved into the building. After that renovation, it seems that the focus of the hauntings shifted from the inmates to the workers. Dispatchers told about hearing file cabinet doors slam in locked rooms after dark when all the employees had gone for the day. They'd also hear strange noises and doors swinging—sometimes slamming. But everyone agrees that all the haunted activity happens at night, usually between 2:00 and 3:00 a.m.

A jail is a unique environment when assessing possible paranormal activity because it's very different from a haunted house or hotel or workplace. When people describe unexplained events in these places there is always that suspicion that an actual person or pet could explain the phenomenon away. Maybe the person telling the story didn't realize that there was actually a person on those stairs, or maybe the informant had been drinking, or perhaps the cat knocked that book off of the shelf. But in a working correctional facility, you KNOW that no one is there. Every part of the building is secured and on camera. To move from one hall to the next, one must buzz the control room (where you are fully visible on camera) and then the door is electronically unlocked. So there are no possibilities that someone is roaming—even an employee can't roam in a secure prison. So if some unauthorized "something" appears to be in those controlled empty spaces it is a *really* big deal.

I interviewed staff members that included the warden, correctional officers, administrative staff and building engineers and technicians. Most of them had between twenty-five and thirty years in tenure. They all had stories about Wish Sheppard. Many of the stories focused on the control

room, which is a secured area in the center of the jail with expansive views of the hallways and wings and camera monitors that show the live activity all around the jail. The control room is like an operations center, and it is occupied by one or more corrections officers. And they have stories to tell. Most all of the haunted occurrences happen after dark when the inmates are locked in their cells and staff is at a bare minimum. Here are some of the accounts told this year (2015) of unexplained sounds and apparitions inside the jail.

Footsteps on the Control Room Stairway

The control room is a square area that has thick glass-paned walls that allow for corrections officers to see in every direction of the inmate areas. There is a panel of computer monitors that displays what the security cameras around the jail are picking up. The control room is where requests are sent to unlock doors for people to move about the jail. You press a button, it rings the control room and you make your request, and they control the doors from there. Above the main floor is a mezzanine where another corrections officer can sit and view any of the camera data on a much larger screen, in case a closer view is needed. To gain access to the control room, one must walk up a set of steel spiral stairs, which are located a few feet behind the officers sitting at the panels and monitors. Several corrections officers—more than three—have repeatedly heard footsteps come up those stairs behind them, and when they turned to see who it is, no one is there. Sometimes two officers will hear the footsteps, and it's not a faraway sound. The stairs are just a few feet behind them. But when they look, there is no one.

Black Spot that Charges the Camera

One instance was particularly disturbing to the officers in the control room. It was the middle of the night. All the inmates were locked in their cells. An officer on the lower level looked at one of the monitors, which showed a vacant room, and noticed a black spot in the corner near the floor. He couldn't tell what it was. He called up to the officer on the mezzanine and said, "Do you see this?" The officer on the mezzanine switched the camera

image to his large monitor to get a closer look. Then the two of them watched as the black spot started to get larger and larger. It then moved closer and closer to the camera until it finally blocked the camera and the monitor went completely black. They were startled and dumbfounded. But then the monitor went back to normal, showing the same vacant room with no black spot. They immediately investigated and found nothing amiss. All personnel was accounted for, and all inmates were in their cells. It was unexplainable.

The Elevator Rides by Itself and Doesn't Like the Second Floor

Another thing that corrections officers notice from the control room is that the elevator will run by itself. This happens in the middle of night when the inmates are locked in their cells. The elevator is visible on camera in the control room. The officers hear it start, they see the door open and they see that no one is on the elevator. One staff member did see on camera what looked like a person standing next to the elevator door. It was a man in a black coat with no visible face.

The guards report seeing shadows walking the halls, loud unexplained noises, doors violently rattling and occasionally a touch that will make the hair on the back of their necks prickle and stand up. One guard said that he once saw a man in black with what looked like a top hat walking along one of the halls outside the control room.

Miss Faye, who has worked at the jail for thirty-four years, said, "I was in a staff meeting in the control room. All the staff was in there, and all the inmates were locked in cells. It was after 10:00 p.m. The bell rang from the prison yard. This is how someone signals that they want to enter the jail. But no one could have been in the yard at that hour. The inmates were locked down, and the staff was in the control room." She said she ignored the bell, figuring it must be a malfunction. But it rang again. So an officer went out to check the door to the yard and the yard, but no one was there.

Cold Spots and Rushes of Cold Air

Lieutenant Brown, the operations commander, has worked at the jail for twenty-six years and said that he was alone in the booking area when he felt

a cold rush of air from behind him. There were no open doors or windows. He spoke to the spirit he believes to be Wish Sheppard. He said, "Shep, leave me alone. I haven't done anything to you." He said that it is creepy to work in a jail and be unnerved by something you can't see. He smiled as he said that the warden reminds the staff to not be afraid of Shep. She says, "Don't worry about the dead. It's the living who will hurt you."

Jeff Porter, who has worked at the jail for over twenty years, says that one particular stairway always has a massive cold spot. He and others have felt that cold rush only when they are ascending the stairway. He says, "You can feel it and expect to feel it whether it's in the middle of summer or dead of winter. That cold air comes at you when you're coming up the stairs. It's a piercing cold."

Wish Sheppard Outside the Jail

Wish Sheppard's presence is also felt outside of the jail, particularly on the old front porch. Staff members said that in the early morning hours they will sometimes go out to smoke a cigarette, and they will sit on the metal green benches that flank the old entrance. The benches are on a covered porch that has four white columns supporting the porch roof. It also has two half columns that are set into the brick. Each of these half columns is beside one of the green benches. They say that when they sit on the benches—especially in the early morning hours—they'll hear what sounds like somebody talking to them from inside the building. Staff never occupies that part of the building when the inmates are in lock down. They know that no physical being is behind those walls, so they figure it's Wish Sheppard talking to them. Sometimes they talk back, and sometimes Wish responds through banging on the half columns. It's happened more than once that the lone smoker will hear a banging on those wooden half columns right near the benches. It's a loud banging. One staff member said that he banged back, and then Wish banged back again.

There's also times when people who are on the Courthouse Green or walking around the town will see the attic light on in the jail. It's a center, third-floor window above that porch where Wish bangs on the columns. People will see a light on and sometimes see the shadow of someone passing by the light. The attic is purely used for storage, and Ron Orendorf, who oversees building maintenance, stated that no one would ever have a need to

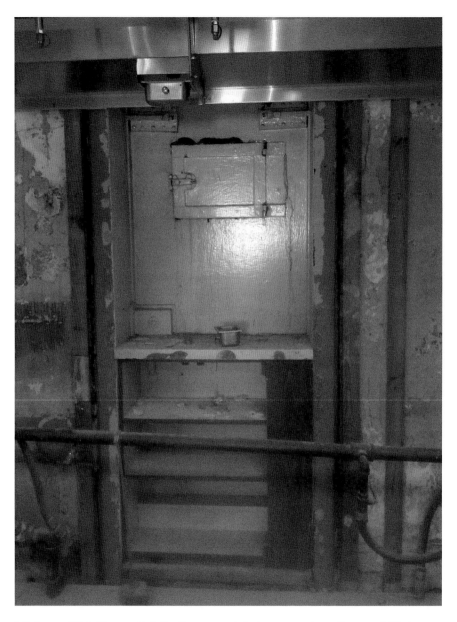

Jail door to Wish Sheppard's jail cell uncovered during renovations. *Courtesy of Warden Ruth Colbourne.*

go up in the attic at night—and even if they did, the light bulb that is by that window has been burned out for years.

I asked to be shown where the door with Wish Sheppard's handprint was. My jail tour guides took me to the commercial kitchen and showed me the wall that now covered the door and the handprint. There was a big steamer against the wall. Warden Ruth Colbourne remarked, "You know, ever since they put the steamer in front of that door it's never worked right. [laughs] And it's a brand-new steamer. It worked fine until we moved it there. Since then, we've had nothing but problems with it."

Evidently the commercial steamer developed problems with the circuit board once it was moved against the wall that was covering Wish's jail cell door. The warden says she's never had a personal experience with Wish Sheppard's spirit, but there were so many interruptions and disturbances when they were trying to get the kitchen done that she did speak to him and say, "Shep, will you PLEASE stop messing with us so we can get this kitchen done!" After that, she says, everything fell into place. She even reached out again and asked for his help when the septic system kept acting up. Though her plea was said in jest, she did ask Shep to help fix the unexplained problems with the septic system malfunctioning. She said that after she asked him for help, the problems seemed to resolve themselves.

One certainty is that the staff who work in the Denton jail—at least the ones who have been there for at least twenty years—fully believe that the spirit of Wish Sheppard is there, is active and does what it wants. There appears to be no skepticism, but there also appears to be no fear. These people seem to care about him. As I was concluding my group interview with the staff, I asked them, "How would you describe Wish Sheppard? Is he angry, mischievous? Is he trying to scare you to death? Does he seem lost?" There was silence. It lasted about ten seconds. Finally, Lieutenant Brown spoke up and said, "Shep is just there. He isn't angry or up to something. He just lets us know that he's there."

Jeff Porter said, "Shep was treated badly all his life. Maybe he's just stuck here, reminding us to be nice to one another…not letting us forget that some people have suffered injustices."

Chapter 3
The Underground Railroad at Linchester Mill

There is a park-like area adjacent to the restored Linchester Mill in Preston. It has a few benches and a little bridge, and it's a nice place to sit and think about what went on in that particular place about 150 years ago. The paranormal investigators have been staking out this park for years and getting readings that show energy and temperature shifts, whitish films in photographs and a low hum or singing sound on electronic voice recordings. Clearly there is a strong energy in this place, and it's only in recent years that ghost hunters have sought this place out. Perhaps the restoration of the mill shifted the energy field in a way that caused a mingling of realms. I have brought bus loads of people to this place, and many of them say they can sense that energy—that feeling of being very alone, but not alone; of being watched; of feeling as if there is movement here, someone over your shoulder, someone behind the mill, someone down at the railroad bridge, someone in the woods. There are many spirits at the Linchester Mill.

The mill was built around 1840 and was one of the last operating water-powered mills on Maryland's Eastern Shore when it stopped operation in the late 1970s. The water from Hunting Creek, a tributary of the Choptank River, powered the mill. But the area behind the mill where Hunting Creek flows was a crossing, an edge, a boundary. Before the Anglo colonists settled in Maryland, when the native people wanted to move north, they would follow the river. The river has many creeks that cut into it. There's Shoal Creek, Cabin Creek, Goose Creek and Indian Creek, just to name several connected to the Choptank. The Indians mapped out safe crossings across

The Linchester Mill in Preston.

these creeks, and the safe crossing at Hunting Creek was at Linchester Mill. Many years later, these same old Indian trails were used for passage along the Underground Railroad in which many enslaved people were ushered to freedom through a network of "agents" and safe houses. The most famous Underground Railroad agent was Harriet Tubman. She was born and grew up in this region, and it's believed that Linchester Mill was one of the "stations" she used when she led slaves to freedom. They traveled by night only, through the forest, along the riverbanks and across the fields.

Safe houses dotted the landscape around Linchester Mill. Quakers, who were notorious for helping slaves escape to freedom, owned many of these safe houses. The homes were stopping places where the freedom-seekers could find rest, a meal and perhaps some news about the road ahead. Free blacks in this region also helped, and they were key links into the slave communities and part of a network of communication that bridged the gap between the slaves and safe houses. And that was a risky position. A free black man named Daniel Hubbard lived near this mill. He had been able to earn enough money to buy his freedom, but his wife and children were still enslaved. He worked as a carpenter and millwright near Linchester Mill and hired the services of his wife and children to help in his business. This kept them all together until he could save enough to buy their freedom. But

in 1857, there was a sting. The Underground Railroad operation at the mill had been discovered. Daniel Hubbard managed to escape before he was captured by an angry mob, but he was never heard from again. Such was the life for people of color.

Defying the white slaveholders could mean a fate worse than death. Sidney (later named Charity) and Levin Still had four children, but they became separated when Levin was sold to a Caroline County farmer. Levin managed to purchase his freedom, and in order for them to be together, Sidney planned an escape—an escape that would likely bring her straight up the Choptank River, crossing at Linchester Mill. Of her four children, the two girls were the youngest. Sidney knew she couldn't escape with all four of them and get from Dorchester County to points north where she'd be free. She had to choose to leave two of them behind. She knew that the boys would fare better than the girls, who would be subject to sexual assaults and left unprotected. So she made a run for it with her little girls but was caught while moving toward Delaware. She was brought back to the farm in Dorchester County, and as a punishment, her owner sold her two sons to a slave owner in Kentucky, and from there, they were sold into the Deep South. Years later, the eldest of the two sons was beaten to death for trying to see his wife and children on another farm. Sidney made another attempt at escaping and succeeded in joining her husband, Levin. They settled in New Jersey and had thirteen more children, the youngest of whom was William Still, the father of the Underground Railroad. He is credited with helping over eight hundred slaves escape to freedom. Forty years after that first failed escape, Sidney was reunited with her surviving lost son. It was a miracle.

The Hunting Creek crossing behind Linchester Mill was also a reverse Underground Railroad. There were slave catchers and kidnappers who would snatch free blacks and move them south to be sold as slaves. It was big money. The slave catchers would take the same route as the Underground Railroad, only they'd be heading south instead of north. Up through the 1950s, hunters and farmers were finding shackles still nailed to trees on the this route where the slave catchers would shackle their victims until a ferry arrived to take them down the river. The most famous of the Mid-Shore slave catchers was Patty Cannon (whose story is covered in more detail in my *Haunted Eastern Shore*), and people like her were the worst of the community. They exploited others, betrayed their neighbors, murdered for money and were feared by most.

If human emotion can put an imprint on an energy field, then Hunting Creek and the tract of land adjacent to Linchester Mill is surely full of that

fear and hope that was burned into the place during that terrible time when the Underground Railroad was in operation. We see this emotional burn in places like Gettysburg and Antietem where the battlefields still seem raw from all the carnage that took place. We see and feel it in sites that memorialize greatness as well, like the Lincoln Memorial in Washington, D.C. We also feel it in an old homestead where generations of have lived out happy lives—or sad ones. Emotions shape the sense of place, and when those emotions are collective and shared by many people, it burns a hole in the energy field and allows the spirits to pass through with more ease.

Hunting Creek was the last crossing on the long trek to freedom. The hope and joy felt by those who made the crossing and those who helped them has imprinted itself here, as has the sorrow of those who didn't make it and those who were led from freedom to slavery. It's interesting that one of the sounds the paranormal investigators obtained off the EVP (electronic voice phenomenon) recording at Linchester Mill was a low hum or low singing. The African American community on the Mid-Shore tells the story of how slaves were singled out for rescue by "agents" and "conductors" like Harriet Tubman of the Underground Railroad. They say that while they're working in the field, a signal would come. That signal was the faraway sound of someone singing, "Swing Low, Sweet Chariot." When they heard that, they knew that someone would be coming and some lucky slave or two or three would be making their way to freedom on the Underground Railroad. It was part of the code, the system they used to communicate. And some people say that you can still hear them singing, not just at Linchester Mill but also in the farm fields of Dorchester and Caroline and on the banks of the Choptank River. It's a faint sound, almost a whisper. But they still hear it.

Chapter 4

Cannon Hall and Maggie's Bridge

Every once in awhile, there's a place that seems to be surrounded by ghosts and bad karma, a dark energy that seems to attract like energy unto itself. Woodland, Delaware, is one of these places. Though the dark energy is old and Woodland now has a beautiful waterfront with a ferry that connects the Seaford area with Laurel, Delaware, the memories still hang there. Woodland was the site of a murder, accidental death and a mass grave of unremembered dead—and all three incidents were totally unrelated.

Woodland is a little waterfront village in Sussex County that sits on the Nanticoke River. I've included it in the Caroline County section of this book because it is just over the county line and is loosely linked to Patty Cannon, the famed slave catcher and kidnapper whose tavern is believed to have been in Caroline County. Woodland is most famous for its ferry, but just across from the ferry landing is a house—now being rebuilt—that once belonged to the Cannon family. Beside the ferry landing is believed to be a mass grave of smallpox victims, and just up the road about a mile is Maggie's Bridge, a bridge believed to be haunted by the ghost of Maggie Bloxom, who lost her head (literally) in a carriage accident.

In 1740, James Cannon began a ferry operation on the Nanticoke River right where the Woodland crossing is today. He built up the area as a wharf and began doing a few trade operations. When he died in 1751, his son Jacob took over the operation with his wife, Betty. Jacob further expanded the wharf and the enterprise. He began building what would become a multimillion-dollar business of shipping, money lending, real estate

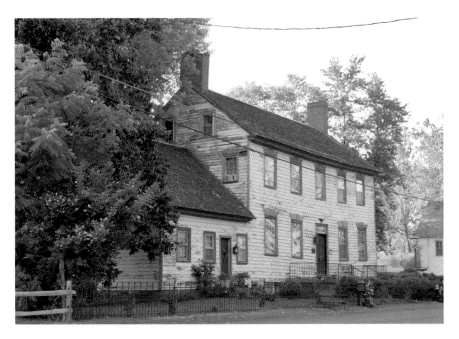

Cannon Hall in Woodland, Delaware, before it caught fire.

acquisition and international trade. Jacob's first cousin Levin was the father of Jesse Cannon, who married Patty Cannon. They had a daughter who married Joe Johnson. These Cannons and Johnsons developed a human trafficking ring in which they kidnapped free blacks and slaves, sold them into the Deep South and murdered people to keep their cover.

Jacob Cannon died in 1780, and later that year, Betty gave birth to a son, Jacob Jr. She took over the ferry business and eventually ran it with her two sons, Isaac and Jacob Jr. They expanded the wharf, bought up property in Delaware and Baltimore and developed a good amount of wealth. They all lived right there around the wharf, which was eventually named "Cannon's Ferry." The Cannons were slave owners. In 1840, at the peak of their success, the Cannon enterprises owned thirteen slaves. Jacob and Isaac also had seventeen personal slaves between them.

Jacob Jr. built a beautiful four-thousand-square-foot home on the waterfront in 1820. It was (and still is) called Cannon Hall. He built it as a wedding gift for his beloved fiancée. But the girl ran out on him before the wedding, and Jacob never moved in. In fact, the State of Delaware records show that the house was vacant for over twenty years and eventually passed to Jacob Jr.'s sister Luraney after he died.

Though the Cannons had built up a huge business at Cannon's Ferry, they were not well loved in the community. They were seen as thugs and self-serving exploiters who gave little and took all that they could. Numerous lawsuits were filed against them. One newspaper reported that Isaac Cannon was said to have taken beds away from the sick to collect his debts. On April 10, 1843, Jacob Jr. was shot to death in broad daylight right at his wharf. His assassin was Owen O'Day, who owed Jacob Jr. a small debt incurred in a business deal. The Delaware courts indicted O'Day for murder, but law enforcement didn't seem to try to stop O'Day from fleeing the state, and no one ever pursued him. One month later, Isaac died from natural causes, and the Cannon legacy came to an end. In his autobiography and diary entitled *Life in Sussex: 1780–1857*, William Morgan wrote, "After fifty years, cheating, oppressing and distressing, selling and taking every thing they could lay hold of, there they lie in their graves unlamented and unmourned by any except a few flatterers. One for his oppression and cruelty was shot in cold blood and died as a beast. The other was permitted to die in his bed! But money was his God."

William Morgan also stated that he rented the only house in Cannon's Ferry that was not owned by the Cannons. There are other complaints by residents about the Cannons providing terrible service and making people stand out in the cold and rain. The Cannons provided no tavern, as most ferry locations had, where people could comfortably wait and have a meal before they set out on the next leg of their journey. Yet Cannon Hall remained empty right across from the wharf. In the end, these two men died with few to mourn them, and their heirs mismanaged their estate and lost much of the fortune they'd built. Jacob and Isaac's sister Luraney moved into Cannon Hall.

The Mistress of Cannon Hall

The wedding gift Jacob Jr. built for his bride may have started out as a lonely shell with little love in it, but it eventually became a well-loved home filled with the joy of its owners who lovingly restored it. A.V. and Marilyn Griffies bought Cannon Hall in 1994 and moved in with their son, Jeff. They became prominent figures in Sussex County historical preservation. They opened their home to visitors and gave historic tours. They loved their home, and they loved sharing it. I had driven by Cannon Hall several times in 2009

when I was doing research on Patty Cannon for *Haunted Eastern Shore*. I'd read that Cannon Hall was linked to Patty, but when I found out that the owners were distant cousins of Patty's husband, I didn't pursue the Cannon Hall property. However, I still admired it, and I stopped and looked at it. If ever a big old house seemed haunted (at least from the perception one could get from standing outside), Cannon Hall seemed to have spirits or something. The whole area had some kind of strange feeling to me.

In 2010, I was organizing a haunted bus tour of Dorchester and Caroline County and was going to put Maggie's Bridge on it and the area near the Woodland Ferry. The week before, I usually do a dry run of the tour, so I headed out for Woodland. It was Sunday, October 31—Halloween day. I was shocked to see that Cannon Hall had been consumed by fire. The site was horrific. This old icon that had been there on the shores of the Nanticoke for two hundred years had been violently destroyed. The first floor was boarded up, and the second floor had no outside walls, only singed beams. The roof was burned off, and all the windows on the sides were knocked out. The owner had put up Halloween decorations before the fire, and they were still there, neatly placed beside the porch with the broken railing and singed wood lying on top of them. A crisp, white sheet–like ghost swayed in the wind from the lamp post about six feet away from the burned building. Another ghost swayed in a window that had been broken out of a second-story bedroom. Pumpkins and gourds were lined neatly against the iron fence, and an old scarecrow decoration had fallen down beside the house right next to a huge charred beam. The site was surreal.

Then I noticed her: a lady sitting on a bench by herself next to the burned-out house. There was a camper in the driveway with the door open, and then I figured it out. She must be the owner, staying in that camper until she could figure out what to do. She noticed me, and I said hello. Then I thought about how she might feel if a bus load of fifty-five people unloaded in front of her house next weekend and started gawking and taking pictures. It seemed inappropriate. When she approached me, and we started talking, I found her very friendly and most willing to share any information about the history of her beloved Cannon Hall.

Marilyn Griffies was very gracious. She shared many stories with me about Cannon Hall and the good memories it had for her. The fire had started in the dining room two weeks prior. She had been in the barn that was behind the house and didn't know the fire had started. By the time she discovered the blaze, it was too late. The fire had consumed most of the house. She shared stories about her husband and son, the parties, the

The Haunted Mid-Shore

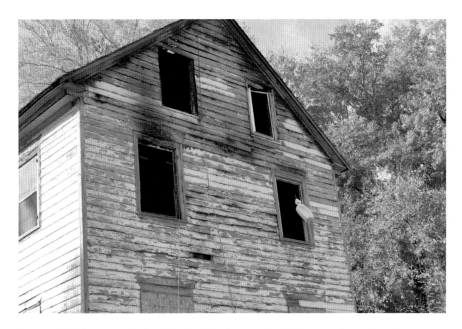

Cannon Hall just after the October fire that destroyed it. Halloween decorations hang unsinged in the window.

renovations and the times they'd all had there that were so memorable. I told her about the ghost tour, leading up to the idea of a bus load of people being there the next weekend, and she said, "Are you going to tell them about our ghost?" She said certainly the house had a presence. She believed that the spirit in her house was Luraney Cannon. She knew it was a woman because she'd seen her.

Marilyn described her first encounter. She'd lived in the house for about a year. She was in the kitchen cooking and heard someone above her in the kitchen attic, where her son's office was. Both her son and husband were at work, so she assumed it was an intruder. She shut off the television to listen closer. There was definitely someone in the attic. She telephoned the police immediately, and they came and searched, and they found nothing. The only exit would have been through the kitchen door, and she had been standing by it until the police arrived. She heard the noise again and sent Jeff up to see what it was. He went upstairs and saw nothing, but as he was going down the stairs he distinctly felt the touch of a small hand—a woman's hand—on his shoulder near his neck. Though he was startled, he wasn't afraid. He paused for a minute, and the hand released him. He looked up the stairwell and saw no one. He

went back up the stairs and looked around the attic, but there was no one there.

Marilyn said that when she heard the steps in the attic again, she went upstairs, and this time she saw the woman. However, she only saw the woman's face—and it was coming right toward her. Marilyn kept her eyes on the face until it dissolved. Marilyn says that the spirit has always been with them. Sometimes she made herself known with a sound, and other times they just felt her presence. She said she believed the spirit was Jacob Cannon Jr.'s niece. Evidently, his sister Luraney's daughter lived in Cannon Hall for a while. Marilyn also pointed out where Jacob Cannon was likely shot. She said people have seen him there walking through the trees. Then Marilyn told me the saddest story of all. I asked Marilyn what she intended to do about the house, and she said she didn't know. She had lost so much. Both her husband and her son had died recently. She sold Cannon Hall two years later to a couple who are rebuilding, and the circle of ownership continues. It will be interesting to see if the new owners have any encounters with the mistress of Cannon Hall.

Maggie's Bridge

Some time in the late 1800s, Maggie Bloxom was traveling by horse and carriage down the Woodland Church Road about a mile south of the Woodland Ferry landing. When the carriage was crossing a bridge that went over a small branch of the Nanticoke River, the horse got spooked. It reared up, and the carriage went over the side of the bridge and into the water. It was a horrific accident, and young Maggie was decapitated. The local legend has many different versions of what happens when you call out to Maggie from this bridge, but most say that the call must be made at midnight or during the witching hour. If you call, "Maggie, Maggie, Maggie," you might just hear the hooves of the horse on the roadway coming toward you. Call again, "Maggie, Maggie, Maggie," and you might see a shadow coming out of the woods near the bridge. Call a third time, "Maggie, Maggie, Maggie," and she'll emerge from the woods with her head in her hand, wanting you to reconnect it and bring her back to life. One local resident said, "Maggie can be best seen on the night of a blue moon. When her name is called, a strong breeze comes whistling through the trees and little flashes of lights, which appear to be lighting bugs, come from the woods, which have been known

as the Ghost Pits. They come closer and closer with each flash. You really have to see it to believe it." There are other accounts of people's cars acting strange in the area. They won't start or will shift out of gear, or they start to move after the engine has been turned off.

The Smallpox Cemetery

For being such a tiny little village, Woodland has had its share of tragedy and death. The murder of Jacob Cannon on the wharf, the hatred the villagers felt toward the Cannons because of their oppressive control and the death and decapitation of Maggie Bloxom all left some heavy energy in this little village. But most people don't know that there was also a smallpox outbreak in Woodland in 1903. The population contracted it, and the village was quarantined. On December 9, 1903, the *San Jose (CA) Evening News* ran the story that it had picked up on a newswire: "Dover, Del., Dec 9.—An epidemic of smallpox prevails at Woodland, a town near Seaford, Del. Out of a population of about 100 persons there are twenty-five cases of the disease. The town is quarantined."

Hal Roth, in his book *You Still Can't Get to Puckum*, writes that a lifelong resident told him, "My grandfather was living on the other side of the river at the time and traveled by shad barge between his farm and Seaford, paddling upriver on the flood tide and returning on the ebb. He stayed close to the other side of the river hoping he wouldn't catch it." The same resident also told Hal that his grandfather wouldn't help turn the dirt for the graves for all the money in the world because he believed that smallpox never dies. This belief was one of the reasons so many died in Woodland. The fear of smallpox caused residents in surrounding communities to insist that their state government and law enforcement station guards at the entrances to the village and allow no one to leave. People were left with no ability to get supplies, medical attention or food. Some literally starved to death.

The *American Medicine Journal*, published out of Philadelphia, wrote the following in its July–December 1903 issue:

> *Smallpox Victims Dying from Neglect in Delaware*
> *Woodland, a village 6 miles from Laurel, is suffering from a smallpox epidemic, and so strictly is the town quarantined that of the 10 deaths which have occurred, eight are said to have been due to absolute neglect*

and starvation. The president of the Laurel Board of Health appealed to the State Board to send aid to the stricken town, and was informed that no funds were available. Only one family in the town has regular medial attention, the other victims being too poor to guarantee pay. Meetings were held in Laurel church, and money collected for relief purposes. There are 35 cases in a population of 100. The suburbs of surrounding towns are patrolled to prevent refugees from Woodland entering.

Those who died in the Woodland smallpox outbreak were wrapped in sheets and buried in a mass grave that was never marked. It is true that people were afraid to handle the bodies or even go near the graves. They feared that the virus didn't die with the victim, so they were normally buried at the far end of a graveyard, away from the other graves—but in most places, only one or two people suffered this fate. Woodland had so many that a mass grave was the wisest choice of the day.

No one knows for sure where the burial site is, but there are two local stories about the location of that mass grave. One suspected location is somewhere behind the Woodland Church, and the other is across the road from the church on the little spit of land between the river and the road. This seems more likely for two reasons. One is that there isn't a whole lot of land behind the church where a community could inconspicuously bury ten to twenty-five people and keep them a "safe distance" from the other graves. And secondly, people would be less likely to forget where they buried that number of people if it were in the church graveyard. That spit of land across the street would have been wider one hundred years ago, and being across the road, it had a natural separation. Years of erosion and development around the ferry have possibly washed some burial site away.

So Woodland has its ghosts: the ghosts of Jacob Cannon, the ghost in Cannon Hall, the ghost of Maggie Bloxom and who knows how many unrestful spirits that belong to the smallpox victims. But today those old ghosts have a much nicer setting. Woodland is a bright little community with a nice waterfront park and an active ferry that transports three to four cars as well as foot passengers and cyclists across the Nanticoke for free every day. Cannon Hall has new owners and is being restored. And every September, the community comes together to celebrate Woodland with a festival that includes food, crafts, demonstrations and fun.

Part II
High Street in Cambridge

High Street, Cambridge, and there you are,
A smiling street and an olden way,
Where shadows go by of the dames that dwelt
In the Dorset gardens of yesterday.
—Folger McKinsey

In Cambridge, there is a brick-paved road that stretches from the wharf (also known as Long Wharf) on the south side of the Choptank River and extends into the town's historic commercial district. On either side of this street are stately homes—all historic, some dating back to colonial times. There are mature trees that line the street, some with roots disrupting the sidewalks. On winter nights, the three-hundred-year-old sycamores glow like ghosts, especially when the light of a full moon reflects off their white bark, and the stark, gnarly branches of the lone Osage orange tree seem frozen, almost electrified. In the summer, the same Osage orange tree spreads a huge canopy over the sidewalk and street. And every now and then, the tree will drop one of its heavy fruits onto the bricks below, and walkers should take great care to be out of the line of fire. A falling Osage orange can leave quite a nasty bump on the head.

Every house is different on this road. Each has its own accents representing the upscale style of the time. Some houses have had sections removed and relocated; others have had porches, porticos and galleries added. Two of the houses used to be one hotel until the owner cut the building in two and

The Haunted Mid-Shore

Homes on High Street in Cambridge.

rolled one side ten feet away. Each half was converted into a separate house. The oldest house in Cambridge is on this road, as is the oldest house built in Cambridge. The former was actually built in Annapolis and was later dismantled and brought to Cambridge by barge.

This road is High Street. It's the most haunted street on the Eastern Shore—possibly in Maryland—or the world. There are twenty-six buildings along the two blocks closest to the river. And of those properties, fourteen have haunted stories, legends and folklore attached to them. Some of the stories date back to the 1700s and others are as recent as the present day.

When the British formed towns, they would run a road in a straight line from the port to the highest point visible from the waterfront. They would place the church and the courthouse on that high spot, and the commercial district would fill in around it. They would call this road "High Street." Cambridge followed this process, as did many colonial towns including Chestertown, Boston, Charleston and Portsmouth. High Street is still the most common street name in Britain.

Cambridge's High Street still closely resembles the old colonial model. If the automobiles and electrical wires were removed, the street would look almost as it did centuries ago. From a ship sailing on the Choptank River,

High Street in Cambridge

one can still make out the slow rise of High Street with the steeple of Christ Church capping the rise as it pokes through the tree line.

A stroll down High Street from the courthouse to the wharf and back up to Christ Church is like stepping into a time warp. One can imagine the streets bustling with statesmen, lawyers, politicians and ladies of high society and can almost feel the presence of the old souls that once lived on this street and called it home. This was where the beautiful people lived.

James Michener used High Street as the setting for his book *Chesapeake*, perhaps because there is no street on the Eastern Shore that so emits the energy of the past, and that energy comes from the houses. Each one has a story. Most have spirits. The houses and the trees cling to the old stories, savoring the essence of Cambridge's memories. If you listen with your soul as you walk down High Street, you may hear the spirits speak of the old days—the parties and galas, the great storms, the deaths of little ones, the cries of slaves sold on the auction block, the prosperity of the seafood industry, the Great Depression and legacies of brilliant leaders who laid the foundation of a thriving town that has grown, prospered, faced countless challenges and has remained a jewel of the Eastern Shore. If you want to meet the spirits, walk High Street at the witching hour.

CHAPTER 5
THE CROSSROADS OF JUDGMENT, PUNISHMENT AND REDEMPTION

The folklore collections are full of eerie references about the area where High Street crosses Church and Spring Streets, but almost all of the references have to do with sounds, particularly the sounds that people hear at the witching hour. There are many accounts of strange occurrences, but sound is the common focus. There are reports of the strange sound of the wind rustling through trees that are no longer there, the sound of yelling and jeering when the area is deserted and the muffled, raspy whisper of children chanting what sounds like, "What were you hung for, Bloody Henny?" And there's a high-pitched vibration radiating from a large yew tree and the faint sound of a woman singing church hymns. Sound is generally the most common way people experience the otherworld. But it seemed strange that there were so many variations of sound phenomena in this region and an uncommonly high number of references to the "just after midnight" hour.

Midnight has always been viewed as a mystical time—a time of passage and transition, a time when a new cycle begins, a new revolution of the earth starts. It's a time when our psychic sensitivity is at its peak. Literature in many world cultures shows this as a time when otherworldly creatures come out, and the thin veil that separates this world from the otherworld opens. Perhaps this is true, or perhaps we are somehow conditioned to be more sensitive to what's around us at this time. Or perhaps this area has a little wormhole that allows us to peek into the past and connect with people and events that were wrapped in high human emotion.

The Dorchester County Courthouse on High Street.

The area at the intersection of High Street and the crossroad that is Church Street running west and Spring Street, running east, is the high spot where the Cambridge colonists placed the courthouse, jail and church. It was an area of community institutions that eventually drew in every resident. It was a place of gathering, of commerce and trade, a place where one could find the news of the day. It was a place where everything legal happened—land recording, the filing and execution of wills, the handling of orphans and civil disputes, trials and sentencing. This crossroad was also a place of punishment where prisoners were incarcerated and corporal punishments were carried out in a public square. And it was, of course, also the place of meting out the ultimate punishment—public executions. On a more positive note, this area at the top of High Street was also where people celebrated, worshiped, got baptized and married and were laid to rest once they passed permanently into the otherworld. The people of Cambridge were judged, punished and redeemed all on this one crossroad.

If you believe, as I do, that human emotion can impact an energy field and that our own personal energy field can connect with waves from other fields, then it's no wonder that so many supernatural experiences are reported in

this locality. We feel differently when we linger at this crossroad. That feeling is magnified at night, and more so when there's moonlight illuminating the darkness. Why? Think Gettysburg or Antietam. The sense of what went before in that particular place is amplified the more we tune into it, and this gets even stronger after dark. The sheer terror, anguish and carnage that took place on those battlefields where thousands upon thousand of young men were brutally killed, maimed, dismembered and left for dead far away from home has burned a strong impression into the energy fields. We can sense it. We can almost see the shadows of soldiers limping across the fields or lying in ditches. We can imagine the cries, the sense of abandonment. The same is true for this corner on High Street. Though it wasn't the magnitude of Gettysburg, the courthouse, jail and public grounds hold similar memories of death, carnage, humiliation, terror and abandonment.

On the east side of High Street, a courthouse and jail have occupied this space for nearly three hundred years. The first courthouse built on this site burned down in 1851. Arson was suspected. The fire started in the Register of Wills, and all of those files were destroyed. There's been speculation over the years that the fire was set by a member of one of Cambridge's wealthiest families who had recently discovered that he'd been excluded from his father's will. At the time, Edward LeCompte was serving as the deputy registrar. The only surviving documents from the Register of Wills were the Minutes of the Court, which LeCompte had taken to his house that day. The courthouse we see today is the second to occupy this lot. Up until 1994, there was also a jail just behind the courthouse. In 1970, a bomb exploded in this courthouse, blowing out a corner of the building. It was placed in the women's restroom and evidently had a timing device that caused it to explode in the early morning hours. There were no injuries. The bombing was believed to be associated with the trial of H. "Rap" Brown, the political activist who was charged with inciting a riot in Cambridge during the civil rights movement. The conflict between blacks and whites has always been charged with raw emotion in this town. Dorchester County and the city of Cambridge are linked to major occurrences in civil rights history. This was, after all, the region that spawned Harriet Tubman, a famous conductor on the Underground Railroad, military nurse and advisor to President Lincoln. And the great civil rights speaker and writer Frederick Douglass was born in neighboring Talbot County. Cambridge is also remembered as being the site of a civil rights protest gone violent in the 1960s where police fired guns at citizens and a major portion of the black business community was destroyed by fire.

If fires, bombs, court battles, judgments and imprisonment aren't enough to give this complex some bad energy, consider the slave auction block. It was located on the courthouse grounds. Enslaved Africans were marched up from the harbor in chains to be sold to the highest bidder from that block. Today, there is a marker that passersby can read, remembering these unfortunate souls and the terror they experienced. Children were torn from the arms of their mothers, and families were divided in an unknown new world, where everyone seemed to turn a deaf ear. The exact location of the auction block on the courthouse grounds is unknown, but some suspect that it was in Spring Valley.

CHAPTER 6
Bloody Henny at Spring Valley

A low-lying open space on the southwestern side of the courthouse had a beautifully clear spring that bubbled up from the ground. It became a gathering place known as Spring Valley. Today, it is a beautiful spot where people can sit and enjoy the shade of one sycamore tree and a small fountain. But in earlier years, Spring Valley also served as the site where corporal punishment and public executions were carried out. Whipping posts, stocks, pillories and gallows all stood in this place. There are several accounts of the punishments carried out here. A woman caught in the act of adultery was stripped to the waste, tied to the whipping post and given thirty-nine lashes in public. Then she was sent to the pillory to stand for several hours, subjected to whatever public abuse the locals might dole out. Other forms of public punishment included having one's ears nailed to the post until the poor person finally had the courage to yank his head away, taking whatever flesh was left. Using profanity and lying were punishable by "boring through the tongue" or having one's tongue nailed to a post. The punishment for drunkenness and robbery was being branded on the forehead with a hot iron and forever labeled a criminal. The ultimate punishment, of course, was hanging, and public executions were held at Spring Valley.

The most famous execution at Spring Valley was the hanging of "Bloody Henny" in 1831. Henny was an enslaved African American female who lived on the Insley farm near Vienna. On a Tuesday morning in February, Henny complained to Master Insley that she did not get a sausage on her breakfast plate. Master Insley was furious about her complaint. He beat her

and berated her for being so impertinent as to expect more than what she was given and then complain about it. As he was leaving to go about his work, Henny warned him that he would regret beating her. He paid little attention to her threat and left.

Later that morning, Henny was assisting her mistress, Mrs. Betsey Insley, with the family's washing. As Mrs. Insley—who at this time was in the advanced stages of pregnancy—stirred the large kettle of boiling lye, Henny found a sausage and then deliberately dropped it into the wash kettle. Mrs. Insley screamed at Henny and scolded her for being so careless and contaminating the wash, which was in a large kettle of boiling lye. Henny scooped out a quart-sized cup of the wash water and threw it in Mrs. Insley's face. The mistress screamed violently and began to thrash about. Meanwhile, Henny ran to the woodpile and grabbed an axe. She approached her anguished mistress, who was still screaming from the pain and burning of the lye in her eyes and on her skin. Henny raised the axe and delivered one fearsome blow to Mrs. Insley's skull. According to the *Cambridge Record*, Mrs. Insley's "brains and blood were spattered on the floor, walls and ceiling." Henny continued to hack away until she dismembered the poor woman. Then, in an effort to conceal her crime, she placed the body parts in a closet until she could figure out where to hide them. Still enraged, Henny sought out the Insley's young daughter. According to Henny's own testimony in court, she took the little girl in her arms and carried her to the woodpile with the intent to hack off her little head. But the child's face and her trust in Henny touched some remote sense of compassion in the murderer, and she spared the child.

Eventually, the authorities came for Henny and took her to jail to await trial. It was highly publicized, and newspapers all over the United States carried the story. Henny was described as "short stature, close knit, muscular body, a low receding forehead, small eyes, close together, large ugly mouth, and a face with a contour that was most foreboding." She was sentenced to death by hanging, but on that June day in 1831 when the sentence was to be carried out, there were no gallows erected. There was only a horizontal branch supported by two forked poles. Crowds from all over the county came to see "Bloody Henny," as she was known by then, be executed at Spring Valley.

All of the information about the crime was given by Henny—or so said the news reporters at the time. It was also reported that just before Henny was executed, she made a statement admonishing all those who were cursed with a hot, quick, vindictive temper. She urged them not to allow their passions to get the better of them and that to spare the rod could indeed spoil the

child. The authorities put Henny in an oxcart that was situated under the horizontal branch between two poles. They tied a noose around her neck and wound the other end of the rope around the branch. Then they simply scattered some feed in front of the ox, and the ox walked toward it, pulling the cart behind him. As the cart supporting Henny moved away, she was left to dangle by the neck from the branch. She hung there until she expired.

The story of Bloody Henny has been retold for nearly two hundred years. And for almost as long, people have said that if you walk past Spring Valley at the witching hour, you'll hear a brisk wind rustling the leaves on the massive trees, and inside that sound of the trees will be a high-pitched whisper—like that of a child—asking, "What were you hung for, Bloody Henny?" It was said that sometimes you could also hear the creak of the branch holding her dangling body and the rub of the rope. People were recounting this experience of hearing the wind and the voice at Spring Valley as recently as 1971, and the fact that there are no more massive trees at Spring Valley makes the experience all the more strange.

Across the street from the courthouse is Christ Church. A congregation has been worshipping on this site since 1693. The beautiful Gothic-style church that stands today was built in 1883. The graveyard next to the church has been a burial ground since the latter half of the seventeenth century, with the oldest graves said to go back to 1678. It is the resting place of five Revolutionary War veterans, seven Confederate veterans and four Maryland governors, with one monument to a fifth governor, John Henry, who was buried close to the Nanticoke River and whose grave was washed away.

Built in the old English style, which has its roots in the pagan tradition, this graveyard is laid out with the graves mostly facing east and an ample scattering of evergreen trees and shrubs that tie into mystical traditions. Evergreens symbolize eternal life. There is no seasonal death with an evergreen. But the most stunning of all the trees at Christ Church is the yew in the front of the yard near the graveyard wall. It sits in plain view and is easily seen by passersby. Yews were sacred in the pagan culture, and they are the oldest living trees in Britain. Yew trees live through many human lifetimes. They reach such an old age because they replace their trunks as the older wood weakens. This gives a ghostly appearance to the yew trunk, which becomes gnarly and bumpy and is known to give off the appearance of having many faces carved it. In the old religion, both pagan and Christian, the yew represents the passage from death to eternal life. The yew was the protector of that spirit that is passing from human life to eternal life. Yew shoots were often placed into death shrouds to protect the passing spirit from

evil. There are old legends about yew trees that thrived and grew quickly when they were placed over the graves of lovers. Somehow the energy of that love fed the tree, nourishing it in otherworldly ways.

This particular yew must have some kind of supernatural properties because it has been known to sing. Folklore collections have accounts of people saying they can hear what sounds like a humming coming from the graveyard at night when the street is quiet. Upon investigation, it appears that the humming is coming from the tree. Some say it's a melodic sound, while others describe it to be more of a vibration. Interestingly, there are some similar accounts that talk about the sound of singing coming from the graveyard. It is the singing of a woman who apparently sings church hymn—but it's not robust, like one would sing in church. It's described as quiet and subtle, the kind of singing one does to pass the time.

The two singing legends are interesting when one considers the possible origin of the yew tree and the grave beneath it. At the base of the yew tree, there are parts of an old marker wedged into the trunk. As the tree grew, it obliterated the grave marker of Ann Weller, the wife of the Reverend George Weller, who was the rector at Christ Church. She died in 1817. Ann was a native of Bedford, New York, and she moved to Cambridge when she married a holy man. It is likely that as the rector's wife, Ann would have had her share of singing church hymns. Ann died young and left behind her husband, the rector, who served only three years in that church community. Perhaps George Weller buried his wife under the yew tree, and as it grew, it destroyed the marker. Christ Church has put a new marker under the tree as a memorial to Ann, and the shards of the old marker are bright white against the yew bark—a reminder of how things change as time passes.

The Christ Church yew tree and the grave of Ann Weller are a stop on the Cambridge Ghost Walk. The guide leads guests into the graveyard after dark and walks them over to stand underneath the massive yew tree. On several occasions, when the guide turns on the flashlight and points it at the ground below the tree, hundreds of beetles, the size of pennies will scurry like cockroaches to the base of the tree and disappear in the bark. It makes for a very eerie setting.

Chapter 7

The Floating Ghost at the Oldest House in Cambridge

The oldest house in Cambridge was not actually built in Cambridge. It was built in Annapolis sometime before 1750 and shipped across the Chesapeake Bay by its owner, a Cambridge merchant named John Caile. In those days (and for the next hundred years), it wasn't uncommon to move houses around. It happened all the time as towns grew and developed. This particular house was colonial in style and quite large. Caile had it dismantled and then reassembled in Cambridge.

John Caile was born in England in 1719 and came to the Eastern Shore when he was in his early twenties. He first lived in Oxford (Talbot County) and began to build his wealth in the tobacco trade, but later he married Rebecca Ennals, and they settled in Cambridge, where John served many years as clerk of the court until his death. Caile's dismantled Annapolis house arrived by barge in Cambridge around 1750, and he had workers rebuild it on the lot currently occupied by the Dorchester Courthouse.

There's an old tale about two workmen who were part of Caile's rebuilding team. The building site was a busy place with lots of ships coming into the harbor, unloading goods and engaging in trade transactions. The workers had the majority of the house reassembled when one of them noticed a British redcoat (soldier) inside the house, staring out of a second-story window. The workman pointed the redcoat out to another workman, and they agreed that it was too dangerous for anyone to be inside the house while it was still in an unfinished state, and they went inside the house to alert the soldier about the safety risks of lingering inside an unfinished building. As

The Josiah Bayly House, the oldest house in Cambridge.

soon as they stepped inside the house, they realized that the second-story floors had not yet been installed. The house was a two-story shell with no floors. The workmen were stunned. They knew what they saw, and they also knew that it was impossible for anyone to be staring out a second-story window unless he was floating.

The workmen never saw the redcoat again, but they talked about the "floating ghost" that had no doubt been attached to the house when it was in Annapolis and managed to cling to the dismantled fragments of the building as they moved by barge to Cambridge. Whether the redcoat phantom was named the floating ghost because he floated across the bay with the house or because he floated to the second story when there were no floors, the story was powerful, and it spread throughout the village, forever to be associated with the Caile house. A few years later, the house was lifted and rolled up the hill to its current location on the west side of High Street, and the sightings of the redcoat began again. People outside the house would see him in the second-story window just as the workmen had.

A story like the floating ghost isn't uncommon when linked to such a dramatic change in a building's environment. Spirit sightings and paranormal activity are most prevalent during renovations or restorations. A common

belief is that the spirits are always with us and around us, but somehow when the environment is disrupted, the energy field shifts and the veil that separates our world from theirs diminishes. We sense them. We see them and hear them. Sometimes we even touch them, or they touch us. The legend of the floating ghost at John Caile's house was still strong more than 150 years after the first occurrence. But it eventually gave way to more powerful spirit stories. Of all the houses on High Street, this one has had the longest history of being haunted.

After John Caile died, the Honorable Josiah Bayly (who was born on Halloween in 1769) purchased the home. He was a district attorney, a Maryland state senator and later became Maryland's attorney general. He also handled high-profile cases where he defended the Eastern Shore kidnapper and slave catcher Patty Cannon and handled the divorce of Elizabeth Patterson Bonaparte, sister-in-law to the French emperor. It was probably because of Josiah Bayly's notoriety that the house became associated with his name and to the present day is known as the "Josiah Bayly House." His descendants owned it for six generations. His son, Dr. Alexander Hamilton Bayly, became a well-known doctor operating a medical practice in Cambridge. Dr. Bayly made many improvements to the house, adding another wing, the double balconies and several outbuildings. But he is most known for the English-style garden he crafted in the large back yard. The old bones of the garden are still visible today. If any owner of this house had passion about its beauty and spirit, it was Dr. Alexander Bayly, and no doubt his presence is still felt. He so impacted the spirit of the community that Folger McKinsey, also known as the "Bentztown Bard," wrote a poem called "Maryland Musings" that was focused on Dr. Bayly and his house and how it dominated and defined High Street. It was published in the *Baltimore Sun* in 1913.

Maryland Musings

High Street, Cambridge and there you are,
A smiling street and an olden way,
Where shadows go by the dames that dwelt
In the Dorset gardens of yesterday.

And here such a garden up the right,
Up from the river, still prim and sweet,
Where Doctor Bayly, in auld lang syne,
Made Eden blossom in old High Street.

The Haunted Mid-Shore

Back from the house, then the dream begins,
And the old box hedges its squares outline,
Where the homely blooms of the olden days
In the grace of the bloomy dreams still shine.

A tamarisk tree, and the smoke bush, too,
And the hollyhocks and the sunflower wall,
And the nameless Grace of a day that is dead
O'er garden and house and the hedge and all.

The friendly doctor—that must be he
Still bending low in the shadow there
In the loved old garden that knew him well
For his gentle pride and his constant care.

A strawberry bed, and a fig tree, fresh
With its green young fruit and its vigorous leaf;
And the noble trees, and beyond the fence
The ancient tombs of parish grief.

The author alludes to the presence of Dr. Bayly still felt in his beloved garden with the line, "The friendly doctor—that must be he still bending low in the shadow there." The last two sentences of the poem have a haunting tone. They refer to the proximity of Dr. Bayly's beautiful gardens to the graveyard at Christ Episcopal Church, with it large trees and its hundreds of grave markers. The only thing that separates the gardens from the graves is a thin brick wall—just like the thin, invisible veil that separates the present world from the spirit world.

The floating ghost isn't the only account of strange happenings at the Josiah Bayly House. Recent owners have indicated odd occurrences as well as sightings of a little girl. A family who moved into the house in the 1990s loved the place. One of the children (now grown) reported that the attic and one of the outbuildings had shackles on the walls—presumably to restrain slaves. According to the resident, they tried to remove them but gave up when they realized they would endanger the old beams that were supporting the hardware. But the attic also held a lot of old stuff that belonged to the Bayly clan, who had owned the house for over 150 years. There were cornbread tins, an old bathtub, clothing and lots of old furniture. One particular item that caught the eye of the new owner was a cheval mirror—a full-length

mirror that fits into an upright frame that allows the mirror to be tilted. The person I interviewed who lived in the house as a child stated that her mother brought the mirror out of the attic and put in her bedroom. Occasionally, when she was alone in her bedroom, she would see a passing reflection in the mirror—very quickly gone. Sometimes she saw the reflection of a moving shadow on the wall, but there was no person in the room to cast the shadow. The woman loved the mirror, and especially loved its connection to the legacy of the house, but the strange reflections left her a little uneasy—but not so disturbed that she was willing to move the mirror.

Eventually, she could see the image of a small child in the mirror, just as plain as if the child was standing before her in the flesh. But there was no child in the room. According to the owner, the little girl was bright and happy and left a sense of cheerfulness when she appeared. We can't know who she was because the owner of the house who saw her has since passed away. But we do know that Dr. Alexander Bayly had two little girls who died young—Sophia and Annie—and they would have lived in this house. They are both buried with their parents in the graveyard next door.

The same family who experienced the presence of the little girl also said there were many unexplained sounds of phantom footsteps and voices that were heard occasionally through the house. The family simply got used to walking in two worlds. There is another story that surfaced in a collection of folklore about the lost boys of Cambridge. A former resident said that "hide and seek" was a favorite game of the children on High Street, and one could hide in the Bayly House and grounds in an endless number of places. Apparently, there were a group of boys playing together in the Bayly gardens, and one of them never made it home. He was last seen at a game of "hide and seek." Perhaps he went down by the river and drowned or fell into a well. But he was never seen again, and those living in the Bayly house would occasionally hear the faint screams of a child—screams that sounded like a cry for help. There's a haunting presence about the house, even on the outside. A recent testimony from a Cambridge local stated that she was standing on the first-floor porch late one evening when she caught the distinct smell of cigar smoke. She could find no one around, and the lights in the neighboring houses were all turned off. Once she could identify the smell, it dissipated.

Whether it's a British redcoat who couldn't break ties with his Annapolis home, the good Dr. Bayly who nurtured the house and raised a fine family there or the children who died in the grace of this old house's gentle benediction, the Josiah Bayly House is still home to some of its former

residents. And the veil between the realms of the living and the dead is so thin there that we can find ourselves uncertain about which side we're on. It casts the perfect mystical shadow at the head of a very haunted street.

CHAPTER 8

The LeCompte Curse

The Federal-style brick house at the head of High Street known as the LeCompte House (pronounced Le-count in Dorchester County) was built in 1803 and purchased in 1842 by Samuel Woodward LeCompte, who was a navy captain in the War of 1812. He served on many fighting ships, including the *Constellation*, *Brandywine*, *Erie* and *Vandalia*. Ownership stayed in the LeCompte family through most of the twentieth century, and it is now the law offices of E. Thomas Merryweather. According to local legend, an ancient Indian curse has plagued the LeCompte family for over three hundred years. It dates back to the first LeCompte to settle in America.

Antoine LeCompte was born in France but later became a war hero in England. He was granted a patent for seven hundred acres along the Choptank River in 1659. This area is now known as the neck district of Cambridge, and it is bordered by LeCompte Bay, which is named for him. When the land was granted to Antoine, the Choptank Indians were settled on his land. In fact, during the time Antoine LeCompte moved onto the land granted to him, there were many more Indians in the Dorchester region than there were colonists. The Choptanks were peaceful people for the most part. They normally resisted conflict, took the path of least resistance and were more passive-aggressive than aggressive. When they were asked to move off the LeCompte lands, they would move, but then they would return. Antoine LeCompte had people working his plantation who would run the Choptanks off of his lands, and he also had a pretty good weapons arsenal. But eventually, Antoine LeCompte wanted a final solution to

The LeCompte House on High Street is now a law office.

moving the Indians off this land, and story in a folklore collection I found in the Dorchester County library tells how he finally did it.

Antoine LeCompte, under the guise of making peace with the Choptank Indians, invited the Indian chief of the local tribe and his sons for dinner at the LeCompte home. After the meal, they all retired to the barn to smoke. No one knows why, but Antoine LeCompte ended up shooting both the chief and his sons to death in that barn. Some say there was much drinking done during dinner, and talk of land ownership led to a violent argument that ended with the death of the Indians. Others say Antoine LeCompte murdered the men in cold blood to scare the Indian tribe into permanently vacating LeCompte lands.

The Indians did vacate the lands. But they also placed a curse on the LeCompte family saying that because Antoine LeCompte was blind to the ways of peace, his sons and descendants will suffer blindness. Antoine's son Moses did go blind, as did nine of his eleven children and over forty LeCompte descendants. In a commentary written about the LeComptes in

1819—shortly after the LeCompte House shown in the image in this chapter was built—nineteen of the living LeComptes were blind.

Melanie Merryweather and Warren Papin wrote a beautiful commentary about Captain Samuel Woodward LeCompte, who liked to be addressed as "Captain." He was a descendant of Moses LeCompte, who was the son of Antoine who went blind and had so many blind descendants. The Captain's portrait hangs in the Meredith House (now part of the Dorchester County Historical Society complex), and he is described as a "handsome gentleman in uniform, a saber on his left side and a pleasant, almost smile on his face. His youthful appearance is aged slightly by the muttonchops that sweep down the side of his face but give balance to the lack of hair on a high forehead."

We know that Captain LeCompte was devoted to his wife and daughters through a collection of his letters, all of which were signed simply "LeCompte." We also know that his two sons died when they were very little and that he lived in the LeCompte House for twenty years until he died at the age of sixty-eight. He is buried across the street in the Christ Church graveyard.

The LeCompte House is not a major stop on our Cambridge ghost walks, and it has no specific ghost story attached to it. The guides stop there primarily to talk about the Indian curse and how blindness still plagues adult males in the LeCompte family today. But something about the LeCompte House intrigues our guests, and it is one of the more photographed buildings on the tour. It is also one of the buildings that shows an unusual amount of anomalies in digital photographs taken by ghost walk guests. Even more surprisingly, the anomalies are similar even though totally unrelated people attending the ghost walks over a period of about a year shot the photographs. Understand that guests take many pictures on all of our ghost walks, and 90 percent (or more) show nothing out of the ordinary. But we've accounted for seven instances where guests got oddities or irregularities in their digital images of the LeCompte House. Six of them were of a shadow or what appears to be an outline of a person in the attic window (third floor). The seventh was a strange, dark shadow on the front porch.

CHAPTER 9

THE GHOSTS OF THE LEONARD HOTEL

There are two buildings closely situated on High Street that used to be one building. Nos. 118 and 120 were once one very large house that was built in 1790. Cambridge had a bustling port at that time, and much of the port activity occurred just behind these houses. Because of the transient people who would come in on ships and need a bed for the night, there was a need for a hotel. In the late 1800s, a sea captain from James Island named James Leonard got tired of the harsh life of an oysterman. He bought the large house and converted it into a hotel. He brought his wife, Mariah, and their four children to Cambridge by barge and moved them into the building, and they began life as hoteliers. Mariah died shortly afterward, leaving James to run the hotel while managing to raise four children. Within a year, James married his second wife, Kate Robbins, who gave birth to a child shortly thereafter. The burdens of operating the hotel and managing such a large family became too difficult. But rather than sell the hotel and find a new house, Captain Leonard sawed the building in half and rolled one part of it fifteen feet down High Street. Each side of the building was converted into a separate house. Captain Leonard lived in one house and rented the other one out. Over the years, trim and moldings have been added, and it's difficult to tell that the two buildings were ever joined. One side of the houses, the side that used to house the public rooms of the old hotel—the hotel dining room, lounge area and kitchen—has a history of being haunted. Most of the stories were recorded when the Dorchester

High Street in Cambridge

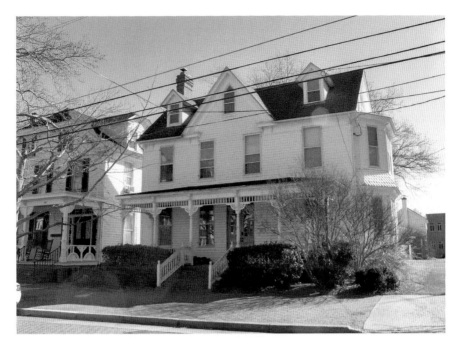

The Leonard Hotel. This was half of the hotel. The adjacent house was the other half.

Centre for the Arts, which occupied the building in the 1990s, began to do major renovations.

There are many ghost enthusiasts that believe renovating properties stirs up paranormal activity, and it's true many people have their first "haunted" experience when they start renovating. But as someone who has interviewed over one hundred people who have a ghost story to tell, I've noticed that most people start renovations when they move into the property. So is the spirit world reacting to their environment being interrupted, or is it reacting to new people? It's a worthy question. In the case of the Centre for the Arts, the renovations did commence right when they took over occupancy.

A director of the Centre for the Arts named Susan told a story about how she was alone in her office when she heard the doorbell downstairs ring. She called out but received no response. The center was closed, and it was after hours. Susan tiptoed to the second-floor landing to see if she could see someone at the door. The front door was swinging open. She closed the door, but the minute she returned to her desk and sat down, the bell rang again. Again, she crossed to the landing and saw the door

swinging wide open. She locked the door and went back to her desk, and when the bell rang for a third time, Susan called out, "This is NOT funny. Stop it!" It didn't open again.

Several months later, a staff person named Rita was also alone at the time and heard the supply closet door creak open. That door is held in place by a hook and latch. It is physically impossible for it to swing open without someone or something lifting the latch, yet Rita distinctly heard it open on its own—repeatedly.

And older man who once used the communal dark room at the center said that he would always bring his radio with him when he worked alone in the building. He'd finally had enough of hearing spirits crying and walking around up and down the stairs. The radio made it so he wouldn't hear anything outside of the dark room. A volunteer at the arts center admitted that the ghostly activity in this house when it was the Dorchester Center Centre for the Arts was part of the reason the group had sought a new location. The volunteer stated, "They knew they needed to expand, but the haunting made them speed up the process. The paranormal activity was unnerving."

Captain Leonard and his wife and children entertained many guests here. Many old hotels and inns have residual energy from past guests. But the spirits in this house weren't just shadows wafting down the halls. They were interacting with the human occupants. It could be that they were always there, and no one noticed. Or it also could be there is a "thin place" in this property—a kind of portal to the eternal realm—and spirits come and go.

In the summer of 2014, another ghost walk guide and I escorted Eastern Shore writer Helen Chappelle on a private ghost walk. Helen was writing a Halloween article about Eastern Shore ghosts. As we stood in front of the Leonard House, which was once the Dorchester Centre for the Arts, the front door slowly opened. An older woman in a white gown stood in the doorway staring at us. I tried to tell her what we were doing, hoping we didn't frighten her by standing there too long. She finally heard me say that we were highlighting some of the properties on the Cambridge Ghost Walk for a local writer, and we introduced Helen. The lady looked at all of us and said in a forceful voice, "I am not a ghost." We had a little laugh and then she invited us in and showed us many of the wonderful renovations she and her recently deceased husband had done to the house. They'd lived a full life in Baltimore and were devoted to historic preservation. They bought this home not only

to be their home in retirement but also as a renovation project. Sadly, he died shortly after the renovations were complete. She told us that she didn't believe in ghosts and that the house was not haunted. We had a lovely visit that lasted almost thirty minutes. As we turned to leave, she mentioned that her cleaning lady often sees her husband in the living room (the old hotel dining room).

CHAPTER 10

THE MAN WHO WAS BURIED WITH HIS DOG

Winder Laird Henry was born in 1864 and served as a U.S. congressman. He built the Laird Henry House in 1890 and raised his son there. The house is built on a tract of land that was once known as "Old Common." The land stretched from the street down to the river and was later subdivided. Both Laird Henry and his son practiced law in Cambridge until their deaths. The house has always been known as the Laird Henry House since Laird Henry died in 1940.

In recent years, an older lady lived alone in the house, and her son looked in on her. After she passed away, the house stayed vacant until early 2015, when it was finally sold. Prior to that, the neighbors next door kept a key for the owner so that they could assist realtors who were showing the house. The owner admitted to these neighbors that the house was haunted. He said that weeping, screaming and sounds of utter despair were sometimes heard coming from the attic. He also told the neighbors that a girl who had mental disabilities once lived in the house and that she was kept on the upper floors.

It was not uncommon in these days for families to lock away members with mental disabilities. It was inappropriate to bring them out in public, and there was little proven treatment. Since these mentally disabled people often acted out in public or made others uncomfortable, they were not accepted in society, and they were difficult to care for considering the lack of resources and public acceptance. Many of these poor souls were sent off to live in asylums, and their families rarely got to see them. But wealthy families had larger houses, and many of them kept these loved ones with these disabilities

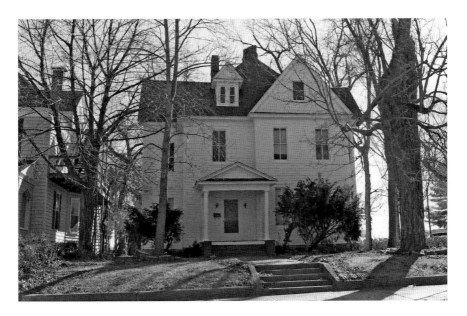

The Laird Henry House on High Street.

at home. But sometimes it was necessary to restrain them for their own safety and to shield them from the ridicule they'd receive in public. Some families were kind and caring, but some families weren't.

When I was researching properties for the Cambridge ghost tour, I happened to talk to the Laird Henry House neighbors. They mentioned that the owner had said it was haunted. I made a mental note to research it further and try to track down the owner. I never did contact him, however, and I wasn't successful in getting the stories verified by someone who lived in the house, so we didn't put the house on the tour. But every time I guided the Cambridge ghost walk, I got a weird feeling when I passed the Laird Henry House—not a bad feeling, just a feeling that the house was teeming with energy. This is not typical for a vacant house—at least not for me.

About a year after our conversation, those neighbors who originally told me about the Laird Henry House attended a Cambridge ghost walk. Our guide Missy led the walk that evening, and she admitted to feeling weird vibes when she passed that house. The neighbors offered to give her a tour inside since the house was vacant and for sale. Perhaps Missy would know someone who might want to buy it. Missy said there were a lot of things in the house that were striking or unusual and seemed to have a story behind them, like the perfectly pressed Vietnam War–era military uniforms hanging

in one of the second-floor closets. As they walked through the house, the neighbor elaborated on the ghost stories that the owner had told him.

Apparently there is a ghost named Simon who causes a lot of mischief, and there is the spirit of a young girl who has been seen on the upper floors. She wears a high-necked gown and walks the upstairs halls. Sometimes she screams. Sometimes she cries, wailing in such a way that she seems inconsolable. She's also been seen in the attic, and her screams and cries have also been heard coming from there. No one can verify who Simon is or where that story got started, and the identity of the young, sorrowful woman is also a mystery, but she's been seen and heard by several generations of people associated with the Laird Henry House. The story of that young woman has been told and retold by many who live in Cambridge. Some people who retell the story say that the woman was a mentally ill relative of the Henrys who was kept on the upper floors, while others say she's an unrelated phantom spirit who settled there.

The Laird Henry House also has a powerful tale of the dead. Up until the house was sold to its current owner, there was a painting of "Grandma Bea" on the wall in the living room. Bea Murphy, a former owner of the house, was pretty spunky. After she had been married thirty years, she discovered her husband was cheating on her. Then the husband, his mistress and the family dog were all killed in a car accident. Bea asked the undertaker to bury her spouse wrapped in a sheet with no funeral. When the undertaker protested, she said, "He lived like a dog. He can be buried like a dog." Family members still tell this story today and admit that the funeral service for Bea's husband was played down, but he was buried with the dog.

Beatrice Murphy was an amazing woman. After she raised a family, she started a business and went to college. She was on the dean's list in 1982. At the time, she was seventy-three years old. She also received a Business Woman of the Year recognition from Governor Harry Hughes the same year. She died five years later.

The realtor who listed the Laird Henry House affirmed that there were spirits present and said it was an "active" house. She said that one evening after she'd finished showing the house to a couple, she couldn't find her keys. She searched every room and retraced all of her steps. She finally gave up and asked the next-door neighbors who had a key to close the house and lock the doors. When she got home, she walked into her bedroom and saw the keys to the Laird Henry House on her bed. She knew she couldn't have left them there because she used them to open the house up. Evidently, there is a ghost in the Laird Henry House who travels.

Family members affirm these stories. Anna B. stated, "This was my husband's family who owned the home. The dog was in the car when the accident happened, and he was buried with the dog." The granddaughter of Beatrice Murphy, who also grew up in this house, stated, "I can confirm both of the stories…My grandfather was buried with the dog—Snowball, my dad's childhood dog—and the [weeping] woman who was kept locked in the attic."

We found that many people in Cambridge knew stories about this house being haunted, but there are equally as many stories about this house that were shared by family members who have happy memories of growing up and living in this house, like Grandma Bea's descendants. The house is still beautiful and still standing on the most lovely of all Eastern Shore streets—of course, it's also the most spirit infested of Eastern Shore streets.

CHAPTER 11
A Banker's Unrestful Spirit

The attic of the old Eastern Shore Trust Company on High Street is filled with an uneasy energy. Volunteers working in the evening have reported hearing footsteps in the attic when they know they are the only people in the building. Sometimes they hear footsteps coming down the attic stairs and then down the hallway. Other times they hear faint conversations that seem to come from the old bank boardroom. Today the bank building serves as the home of the Richardson Maritime Museum, which houses boat building tools and watermen's artifacts. It is run by an organization that is dedicated to preserving Dorchester's boat building heritage. Volunteers and board members associated with the museum told us about the strange goings on inside the bank building. Most activity was on the second floor, but some was in the attic.

The local lore states that in 1929, the bank president, in great despair, tied one end of a rope around the attic rafter and the other end around his neck. Then he jumped to his death. Death by hanging—even though it was a self-inflicted death—was an easier fate to face than the public shame of being a financial failure.

We don't know much about George W. Woolford except that he was a very successful businessman and a community leader. He was born around 1862 in lower Dorchester County, and in 1929—the year he died—he lived in a on house on Locust Street just a few blocks from the bank. In 1900 and 1910, the U.S. census shows George's occupation as an oyster packer. This was just one of many business ventures he was connected to. He owned several

Dorchester Eastern Shore Trust Bank. *Courtesy of the Dorchester County Library.*

oyster boats and packed under the name "Goose Creek." His involvement with Levi and Albanus Phillips and Ivy Leonard led to the establishment of the Phillips Packing Company, which dominated Dorchester County's economy for fifty years. That company evolved into Phillips Seafood, one of the largest international seafood distribution companies in the world. George also was a partner in the Woolford Company (a coal and wood yard), as well as president of the Cambridge Water Company, which supplied ice and water to the community. And he was the local agent for Standard Oil. By 1920, he was the bank president at Eastern Shore Trust (formerly Dorchester National Bank), and he also had hefty real estate holdings throughout the city of Cambridge.

There is no record of George Woolford actually committing suicide, but that isn't surprising. Suicide was rarely mentioned in the papers and certainly wasn't mentioned in public. Having a family member commit suicide was shameful. We do know that George was one of the richest men in town and that he was the bank president. We know that he died suddenly in 1929—the year of the bank crash and the start of the Great Depression. And we know that his house was sold shortly after his death and his wife appears to have

gone and lived with relatives. The old-timers in Cambridge tell the story, and in their story, George Woolford took his own life.

Suicide in his time was often a better alternative than facing the consequences of losing one's wealth. There was no safety net in 1929. If a man lost his wealth, he usually lost his family too. For men raising families, it usually meant splitting the family up. The wife and smaller children might live with relatives and find work doing domestic chores, and the older children would be farmed out to other families who would pay their living expenses in exchange for work. It was humiliating, and it was devastating emotionally. But someone like George Woolford would also have to face the shame of going from the top rung of society to the ranks of those standing in the bread lines.

The seafood industry was booming just before the Great Depression, and seafood packers (those who owned the companies that processed and sold the seafood) were resented by most of the community. They set the prices that were paid to watermen and set the wages of those who worked in the packinghouses. George Woolford would have shouldered not only the resentment of the seafood community, but he also probably experienced resentment for controlling rents, foreclosures, fuel prices, costs of building materials and water. And being the bank president, he would have been thrust into the position of being a money collector in many social arenas. So if he lost all of his wealth in the crash of 1929, it's understandable that the burden of shame and impending poverty was too much to bear.

Portrait of George Woolford that still hangs in the boardroom of the old bank.

Maybe his spirit is still lingering where he was at his best, at his peak. The volunteers at the museum believe the presence in the building is George Woolford. A male volunteer says that it's not uncommon for all the staff to be on the first floor and hear activity upstairs—*all* of them hear the activity. Someone will run upstairs to investigate the cause, but they'll find no person and find nothing

amiss. Another museum volunteer has felt a rush of cold air come down the hall on the second floor. She thought a door or window was open, but when she checked the doors and windows, all were sealed shut. More than one person has heard conversations going on in the old bank boardroom only to find the room dark and empty when they investigate. George Woolford's portrait still hangs on the wall in that boardroom. The Maritime Museum volunteers removed the portrait and retired it to the attic when they started doing some renovations to the bank building. Paranormal activity increased, and the volunteers became uneasy, so they restored the portrait to its former place on the boardroom wall, and they give it the respect it deserves. It was still there as of this writing.

Some museum volunteers have said that sometimes the portrait almost seems like it is the presence of George Woolford. We conducted a bus tour of haunted Dorchester a few years back, and the bank building was on the tour. As the guests were shown the boardroom and told the story about George Woolford and the power associated with his portrait, one of the guests approached the portrait and asked her friend to snap a picture. Then she gave the portrait a mock hug and smiled at the camera. The guests boarded the bus to continue the tour, and about twenty minutes later, the woman who had mocked the Woolford portrait became very ill. She was faint, nauseous and dizzy. It came on all at once. At the next stop, she called her husband to come and get her because she couldn't continue the tour.

This isn't the first instance of an object seeming to have the ability to shift or impact an energy field. Some believe that spirits can attach themselves to things. If this is the case, it may offer an explanation of why strange things happen when people disrespect George Woolford's portrait.

CHAPTER 12

TALES OF THE CHOPTANK RIVER

The Choptank River is named for the Choptank Indians who lived on its shores. It's the largest river on the Delmarva Peninsula, stretching seventy-one miles from Kent County, Delaware, to the Chesapeake Bay. There are two county seats along the Choptank—Denton in Caroline County and Cambridge in Dorchester County. But the river actually touches—or rather, divides—all three Mid-Shore counties.

The mouth of the river where it meets the Chesapeake is very wide, with two peninsulas jutting out presenting a gateway into the Choptank channel. The peninsula on the Talbot side is Blackwalnut Point, and on the Dorchester side it is Cook Point.

Cook Point has always been associated with phantom ships. The tides are unpredictable there. The water is choppy and rough with the bay currents accepting the final rush of the Choptank River. A navigation light flashes by Cook Point to warn ships of the shallow sand spit there. That sandbar is famous for causing shipwrecks. Two watermen were fishing one evening at twilight near Cook Point. As the sun set, the watermen saw a schooner heading up the Choptank channel. It had a red and green light on the bow, a white light on the stern and another white light in the center of the ship. The watermen heard no motor, but they heard a dog barking from the direction of the ship's bow. Horrified, the watermen watched as the ship headed straight for the sand bar. But instead of running aground, the schooner disappeared. At various times in the last one hundred years, watermen, fishermen, pleasure boaters and people standing on the point

High Street in Cambridge

The Roosevelt false stack now sits as a monument to FDR at Long Wharf in Cambridge.

have all reported seeing this schooner and hearing the sound of a barking dog coming from the ship. The sightings are always at twilight, just after the sun has dipped beneath the horizon.

Another Choptank River mystery is focused at Long Wharf where High Street meets the river. Just at the end of the paved circle at Long Wharf is a cylindrical monument. It appears to be a smoke stack from a ship, but it's actually a "false" stack, meaning it was meant to look like one, but it served another purpose. It formerly sat atop the USS *Potomac*, which was the presidential yacht for Franklin Delano Roosevelt. FDR was stricken with polio at age thirty-nine and lost the use of his legs. He was confined to a wheelchair, and the false stack camouflaged a hand-operated elevator that he could use to move between floors on his yacht. In 1954, the USS *Potomac* was owned by the State of Maryland, and a Cambridge shipyard did some restoration work on the vessel. This false stack was removed from the ship and presented to Cambridge, which placed it at Long Wharf as a memorial to FDR. Occasionally people have either smelled smoke around the false stack or seen smoke coming out of the false stack. These claims have been made around April 12, the anniversary of Roosevelt's death.

Part III
Lower Dorchester

While Cambridge is the place most people associate with Dorchester County, there is an entirely different landscape to the south. Lower Dorchester—or "down below," as the locals call it—is flat and marshy with rivers and creeks snaking through the land. It's wet, and it's wild. It's brutally hot in the summer, and in the winter, there is no wind as frigid as a Chesapeake wind across the marshland. It's a wild landscape that is sparsely populated. And the people who live in lower Dorchester have been there for ten to fifteen generations. Most made their living off the water or in the maritime industries. They are a sturdy group of people who live a humble life and who tell fascinating stories about their homeland.

House in Crapo in lower Dorchester County.

CHAPTER 13
MARY'S GHOST AT OLD SALTY'S

Old Salty's is a popular destination restaurant in Fishing Creek, which is part of the Hoopers Island chain. The chain consists of three islands on the western side of the county that borders the Chesapeake Bay. All of the islands have causeways that connect them to the mainland. Because of the isolation from other villages on the mainland, the people of Hoopers Island had to be fiercely independent and self-sufficient. Now that bridges, automobiles and paved roads make it possible for island inhabitants to get to Cambridge in under a half hour, that isolation isn't such a big factor. Some of the old buildings sit abandoned, and some have been repurposed, like the old school building that now houses Old Salty's.

The owner of Old Salty's, Jay Newcomb, told me a few years back that the employees say the restaurant is haunted. He admitted he'd never seen anything strange, but he invited me to interview the staff. According to the people who work there, the first to encounter the ghost was an employee named Mary who had worked at the restaurant for years. The ghost talks to Mary and calls her by name. The employees call it "Mary's ghost." According to Mary, there was no paranormal activity until they started moving things off the stage in the room that once served as the school auditorium. The restaurant is on the north side of the building, the bar is in the middle and the large auditorium is on the south side. They used the auditorium for weddings and parties. But one bride's mother asked if they could use the stage during the wedding reception. At the time, the stage was used for storage. But the management agreed to let them use it, and the clean up and

The Haunted Mid-Shore

Old Salty's in Fishing Creek was formerly a school for Hoopers Island.

clean out process began. It was when they started moving boxes out that Mary began to hear this spirit call her name.

Mary said she and her husband were cleaning out things in the auditorium when the restaurant was closed. They were the only two in the building. Mary heard her name called. She assumed it was her husband. When she asked what he wanted, he said he hadn't called her name. Then she heard it again, and this time her husband heard it. They searched everywhere and found no one and no sign of anyone having been there. It happened again when Mary was in the auditorium ironing linens for the restaurant. She was by herself, and she heard someone call, "Mary, Mary."

The disturbances weren't just limited to Mary. The kitchen staff says the shoes, tools and implements will be moved or relocated to obscure places in the restaurant. A bartender said that they have heard crashing sounds in the auditorium as if an entire shelving unit fell over, but when they run and look to see what happened, nothing is out of order. I asked if the voice was the voice of a man or a woman. Mary says it sounds like a woman. But the kitchen staff says the spirit encounters they have are mischievous. They are little pranksters hiding things and pushing things over.

Recently there was a wind phenomenon in the banquet area. The staff was hanging fabric that was to drape in rows from the ceiling. It was part of the banquet decorations. The idea was to fasten the long strips of fabric in two places on the ceiling, allowing the fabric hanging loosely

in a decorative fashion. The staff noticed that the fabric was moving. It was fluttering as if a fan was blowing on it. One of the staff members remarked that someone should turn the fan down until all of the fabric was secured. But there was no fan. There was no open window or door. There was no vent blowing air. They all saw it. Then it stopped just as quickly as it started, and it didn't occur again.

One of the strange occurrences that happens at Old Salty's is the phantom restaurant guest. There is a definite lull after the lunch hour. Around 2:00 p.m., the restaurant is usually empty. Staff uses this time to prepare for the dinner hour. Occasionally one lone guest will enter and not wait to be seated. He'll go straight into the dining room and seat himself. A hostess or server will immediately grab menus and go into the dining room to greet the guest. But the guest is gone. There is no exit out of the dining room except the door through which they entered. The restrooms and the bar are also located near the front door. So the staff sees the man go into the dining room, but he vanishes, and he vanishes quickly.

Apparently there isn't just one spirit at Old Salty's. There's Mary's ghost, the mischievous ghosts who torment the kitchen staff, the spirit that messes with the banquet decorations and the lone guest who walks in but never eats.

CHAPTER 14

THE SEVEN GATES OF HELL AND THE LADY WITH THE LAMP

There's a wooded lane that turns off Route 355 in Golden Hill just before St. Mary's Star of the Sea Catholic Church that is associated with a ghost story about Seven Gates of Hell. People on Hoopers Island told me that years ago, if you went down that lane during the day, there were four gates across the lane. But at night, the realms mingled, and three additional gates would appear. If one had the courage to pass through the first six gates, they would come face-to-face with a bull with red glowing eyes, a manifestation of the devil at the seventh gate, the gateway to hell. Many people went down the lane, but no one who reached the seventh gate ever returned.

There was also a haunted house near the seventh gate. Screams and howling coming from the house were heard not only by travelers walking down the lane but also by watermen and boaters on the Honga River, for the house sat right at the river's edge.

The legend of the lane with the seven gates is coupled with the legend of a Lady in White or the Lady with the Lamp. She appears in several ghost stories that are set around Hoopers Island, but she first appears as an apparition along this lane with the seven gates that leads back to St. Giles Field. She holds a lantern and calls people down the lane, helping them pass through each of the gates. But she abandons them before they get to the seventh gate.

This lane and field were once part of the Tubman plantation—and yes, there is a link to Harriet Tubman, but only through marriage, as the man Harriet married came from these people. The four gates divided different

LOWER DORCHESTER

The haunted lane with seven gates was behind the St. Mary's Star of the Sea Catholic Church in Golden Hill.

pastures. The Tubmans were Catholic, and they donated part of their land to build a church and establish a Catholic community in that region. The church that sits adjacent to the haunted lane was built in 1862 and is still an active Catholic community. The Seven Gates of Hell story has no association with the church other than serving as a landmark to identify the haunted lane and fields behind it.

Several local people confirmed that there were four gates on that lane that led to St. Giles Field. They also confirmed that the Tubman plantation house was set on the Honga River and always considered to be haunted once the house was abandoned. There is also an old cemetery in one of the fields with graves of the Tubman family and others who were members of the Catholic community. Almost everyone I interviewed knew about the legend, and some even claimed to have seen the Lady with the Lamp. Details of the story may have been exaggerated over the years, but this story is strangely still alive. Stories focusing on houses that are no longer there and apparitions from five generations past tend to fade into legend as the haunted activity fades. But this one still had a charge of enthusiasm as well as personal stories that people were willing to share. Mickey D. stated the following:

> *During the daytime,* [the lane] *contained four gates. On some nights, if one should happen to be brave enough to walk back to that lane, there would be seven gates. Supposedly the seventh gate was the gateway to hell. Back on this same property there used to be the old plantation house which was said to be haunted; I have heard that when the property was sold a few years back and a gunning club built there, that at times the noises coming from that old house were so horrendous that instead of just knocking the house down, the new owners dug a deep hole next to the house, pushed it in and covered it over. The womanly figure you refer to at the Catholic Church is locally known as "The Lady with the Lamp." I have heard tales of people having flat tires in front of the church and a figure with a lamp coming out of the graveyard to stand and light the area so that one would have enough light to change their tire on a dark night.*

Heather E. shared, "My dad [Lowell Moore] went there many times. He said he got to the seventh gate and seen the cows and bull and ran! I would shake every time he told the story. There are many other stories from 'down home' he would tell."

I took a drive down the lane (with permission) to see what was back there. Today, there are a few private homes that have been built on the waterfront and farm fields all around. The lane passes the old St. Giles cemetery where lots of Tubmans are buried. It's a beautiful setting there on the Honga River, and I can't imagine it being haunted. But I'm not so sure I'd want to drive down that lane at night.

St. Giles Field and the surrounding fields and homes are on private property and should not be visited without permission from the property owners.

Part IV
Easton and Surrounds

Most Eastern Shore towns grew up around some kind of trade: shipbuilding, seafood, tobacco or produce. But Easton didn't grow up around commerce. It grew up around government. During the early years of the Maryland colony, people held court on the Eastern Shore in houses, and major court cases were heard in Annapolis. There was a crucial need to have a courthouse on the Eastern Shore. In 1710, the Maryland General Assembly decided to purchase land in central Talbot County, where they intended to put a courthouse. The new courthouse was completed in 1712 right along an old Indian trail, which is now Washington Street. A village grew up around that courthouse, and eventually the village was named Talbot Court House.

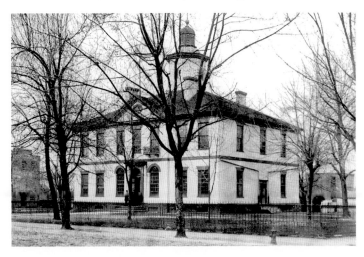

Talbot County Courthouse. *Courtesy of the Talbot County Free Library.*

In 1788, the General Assembly passed a law for holding general court for transactions and determining business of the Eastern Shore. In the same act, the town was officially named Easton, meaning the "Eastern Capital" of Maryland.

Eventually, the town grew to be the second largest in Eastern Maryland, but it all started with the courthouse. Today, Easton is full of ghosts that don't want to leave. They were happy here, and they're still here.

CHAPTER 15
THE COLONEL IN THE COURTHOUSE

All courthouses and jails tend to be haunted. And why wouldn't they be? If you believe that human emotion can impact an energy field and cause that field to shift or absorb the emotions, then the energy or vibration of courthouses and jails are fraught with angst. Nothing good ever happens there. The Talbot County Courthouse in Easton has been haunted as long as anyone can remember. Those who work in the courthouse call the ghost the "Colonel." He makes himself known usually after hours when most of the county employees have gone home. The typical stories are hearing footsteps in the halls or on the stairs and then finding no one there. Sometimes there's a cough and sometimes the smell of cigar smoke. But the presence of the Colonel in the courthouse after hours is so common that many people simply won't stay if they know they'll be alone.

My friend Debbi, who was the tourism director for Talbot County, shared her story with me. Her office was on the first floor on the north side of the courthouse, facing out onto Washington Street. Her window was just behind the Frederick Douglass statue. Debbi would work late in the evening when everyone else had gone home. There's a large staircase just behind the front door of the courthouse that rises from the main lobby. Debbi's office bordered the lobby. When she was alone at night and all was quiet, she'd sometimes hear heavy footsteps coming down that staircase. The footsteps would come across the lobby right to her door, and then they'd stop. She'd wait to see if someone was going to enter her office, and when they didn't,

THE HAUNTED MID-SHORE

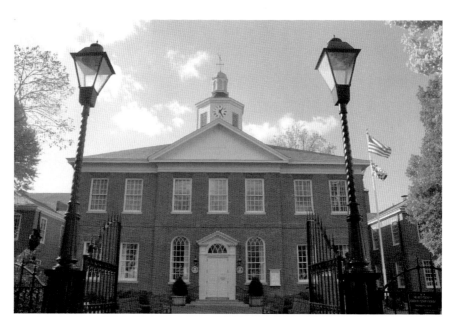

The Talbot County Courthouse in Easton is haunted by a spirit referred to as the "Colonel."

she'd get up to see who was there. No one was ever there. In fact, no one was in the building.

The first time this happened, Debbi mentioned it to her colleagues at work. They told her not to worry. It was just the Colonel. He does that to a lot of people. But it was still unnerving. It happened several more times, and the footsteps would come down the stairs, across the lobby and right up to Debbi's door. But there was never anyone there. One time it happened and Debbi was so swamped with work that she hollered out, "Colonel, I don't have time for this. Will you PLEASE leave me alone?" She never heard the footsteps again.

Just behind the courthouse is the old jail. It now serves as the state's attorney's office. Easton doesn't have a horrible criminal history. While there have been a few executions, they were done in larger prisons in Baltimore, so the courthouse grounds don't have that energy of lynchings and executions the way the Dorchester and Caroline courthouses do. The grounds in Easton are quite peaceful, almost park-like.

There were were no famous villains, murderers, pirates, thieves or other criminals of great fame at this jail. Easton was a pretty peaceful town and still is. The old jail looks just like a house, the same as the Denton jail, and

like the Denton jail, the jailer and his family also had quarters in the jail. The upper floors housed inmates, as did the basement. Usually men were on one side and women on the other. The wife of the jailer or sheriff would see to the personal needs of the inmates. Eventually, a larger jail was built, and this old one behind the courthouse fell into disrepair. But the county recently restored the old jail and renovated it to adequately house the Talbot County state's attorney's office, and the staff there will readily admit that the place is haunted. There are the usual things, the sound of someone moving about, shadows moving across a room and strange noises. But the most unusual event was the sighting of someone who was riding the elevator.

Two staff people relayed what occurred. The building is two stories with a public entrance in the back where a two-story glass wall reveals the lobby the elevator on both levels so that the state's attorney staff and people outside the building can observe anyone going into the building and stepping on to the elevator. This is a very secure building. Two employees were on the second floor talking when they noticed a person waiting for the elevator on the second story, but to be on the second story, one would have had to be admitted to the building by one of these two employees. Neither of them had let the person in. One of the employees walked around the corner to see what the person wanted, but when she opened the door, the person had vanished—in less than three seconds. The other employee also looked up and saw that the person was gone, but also noticed that the elevator hadn't moved and the outside door hadn't opened. This person simply vanished in a matter of seconds. Neither employee could cite any identifying marks. They both said that they saw the person from the back and noticed that the person was wearing a blue jacket and pants. They couldn't tell if it was a man or a woman.

The staff members also say that the basement feels very haunted. It's been converted into a kitchen and eating space. The employees are so sure that it's haunted that they greet the ghosts as they enter the kitchen, hoping to avoid any paranormal mischief.

A strange thing happened after my interview with the state's attorney's staff. Someone who handles bookkeeping in the Talbot County government called the state's attorney's office and asked about a particular phone number for which the office had received a bill. The county records showed that the phone number was attached to a phone line in the state's attorney's office, and the charge for this phone line was strange. It seemed an arbitrary charge for a specific call. No one was familiar with the phone number, and the county didn't have any previous bills for it. The state's attorney's staff told

the county bookkeeping staff that the number didn't belong to their office, but the county staff insisted that the phone was in that building. The state's attorney office went over every phone line and replied back that there was no line with that number in their office.

Weeks later, after some thorough investigation, the county bookkeeping staff called the state's attorney's office back and told them that the phone was in their elevator. It was a phone to be used only for emergencies—like the elevator being stuck—and calls were automatically directed to the 911 emergency center. The charges are billed per minute. The call, according to the billing statement, lasted twenty minutes and was made at 2:00 a.m. when the offices were obviously closed. There was no record of a call coming into the 911 emergency center, and security cameras did not detect anyone in the building at that time.

It's still a mystery.

CHAPTER 16

ARE YOU THERE, MR. GRYMES?

The anchor in the town of Easton is surely the Tidewater Inn. It's the building that everyone remembers. You know you're in Easton when you see the Tidewater. The brick hotel actually stands on the footprint of a former wooden hotel that was built in 1891 and was known as the Hotel Avon. It was a large hotel shaped similarly to the Tidewater but Victorian in style. It had a round tower in the center at the entrance. Staff in the Tidewater Inn said that their grand staircase in the lobby was originally part of the Hotel Avon. The Hotel Avon made Easton a tourist destination. Steamboats brought passengers to the Port Street dock, and horses and carriages would ferry them up to the hotel. Shops and stores grew up in the surrounding blocks to accommodate the tourists' desire for shopping, and business boomed in Easton as a result of the influx of visitors.

But in 1944, the Hotel Avon was destroyed by fire. That loss, along with onset of a world war, forced Easton into an economic depression. There was no money. Building materials and steel were in short supply. Almost no one had any hope of the hotel being rebuilt, and without it, Easton had almost no draw for visitors.

But Arthur Grymes had a dream to replace the Hotel Avon. He began the project in 1947, and by 1949, he had built a state-of-the-art hotel with all the modern conveniences. He built it with brick so it wouldn't burn down, and he even had a professional decorator come in. Mr. Grymes saw to every detail, and he personally ran the hotel.

The Haunted Mid-Shore

The Tidewater Inn, built by Mr. Aurthur Grymes, who still haunts the hotel.

Today the Tidewater Inn is the most haunted commercial building in Easton. Just ask any of the staff. Walter, who often works the night shift, says that he has in the past dozed off on the couch in the lobby. He'll awake to someone pulling his pant leg and then find nobody there. Walter believes this is Mr. Grymes telling him to stop sleeping on the job. Walter also said that one time when he was walking into the kitchen, he noticed a face in a portal window. The face just stared blankly at nothing. So Walter walked outside the kitchen to see who was looking through the portal window. There was no one there. Walter also noticed that the portal window stood about seven feet from the ground. So it would have been a very tall man.

The food and beverage manager hears Mr. Grymes call his name, sometimes from all the way across the Gold Room. He's never visible when he does it, but everyone can hear it. On the top floor where Mr. Grymes's office was, the marketing team has its offices. They admit that they just talk to him. The general manager says she's actually seen Mr. Grymes walking those halls. He wears a black hat and a suit. There was a time when no one on the marketing team would work by themselves on that floor. They could hear his footsteps; they could sense his presence. They felt like he was watching them.

There's also a child spirit at the Tidewater Inn. The child has been seen rushing through the lobby and out into the back patio. At first, the staff didn't realize the child was a spirit. But then when they saw her late at night, they began to wonder why she wasn't with a parent. She skipped out into the next room and seemed to vanish. When they checked the roster the next morning, there were no families with children checked in. The same thing happened about a month later. Again, they thought it was strange, but they didn't think the child was a spirit. It wasn't until a psychic medium checked into the Tidewater and felt compelled to tell the staff about the little girl. The medium described the little girl just as the staff members remembered her. Then the medium told the staff that the little girl is happy there and doesn't want to leave.

CHAPTER 17

MARGUERITE, THE MURDERED ACTRESS

A previous owner of the Avalon Theater explained how one evening in the 1980s, he and his assistant were taking inventory. He was still trying to get the theater renovated and in shape to open in the next few months. The doors were locked and only he and the assistant were in the building. As he explains it, he was on the second floor and the assistant was on the first floor in what is now Banning's Tavern. The owner started to descend the stairs. As he reached the bottom few steps, his assistant came into the theater lobby from the bar, and they both heard the elevator "ding" and heard the doors open. A woman stepped out. They were dumbfounded. She looked at them and then she turned around and walked straight through the theater doors—without opening them. The owner and his assistant ran into the theater. They saw no trace of the woman, but they would never forget her face. The owner started to research everything he could about the theater. He asked all the folks who knew the old stories of Easton, and he found out that there had been a murder at the Avalon Theater many years ago. It seemed a young actress was murdered, and her dead body was found in the Avalon elevator.

The Avalon Theater was built in 1921. It fell into disrepair several times and has been through a series of renovations. Today it is beautifully restored and is open year round with a variety of live performances. The employees at the Avalon—both those who believe in ghosts and those who don't—will all admit that the elevator has a mind of its own. It will randomly run with no one on it. This is particularly alarming when theater

The Avalon Theater. *Courtesy of the Talbot County Free Library.*

staff members and volunteers are there by themselves. All of the sudden, for no apparent reason, the elevator will start to move and will stop on the first floor and then "ding" as the doors open—and no one steps out because no one is on the elevator. The owner had an elevator servicing company come in and examine the elevator and this phenomenon. The service company said that there was nothing wrong with the elevator. It also said that elevators are programmed to respond to intense heat in case of a fire. In situations where temperatures rise to a dangerous degree, the elevator will automatically move to the first floor and the doors will open. Then it will cease to operate. The owner thought this could possibly make sense. If spirits are made of electromagnetic energy, then the elevator panel might be responding to that, which could be why it's moving without a person operating it. The elevator still moves by itself to this day.

As the owner was cleaning out the theater, he came across an old photograph of a line of actresses or possibly dancers. One of the faces looked familiar to him. He soon realized that one of the girls in that picture was the girl he saw on the elevator. The names were written on the back in pencil. She was Marguerite. A large reprint of this picture hangs framed on the lobby wall of the Avalon Theater. Marguerite has

Dancers who appeared at the Avalon Theater. Marguerite is third from the left. *Courtesy of the Avalon Theater.*

been very active, and at least five or six people have actually seen her and recognized her from the picture.

Marguerite tends to hang out in the projection room. Another former owner of the Avalon told of his encounter with Marguerite. He said that he would walk into the projector room and immediately feel a cold spot. He told of the time when they were getting ready to premiere the 1994 film *Silent Fall* with Richard Dreyfuss. It was filmed in Talbot County with some scenes in Easton. The night before the premiere, this owner prepared the projection room, setting the film and projector up so that all was ready for the next night's sold-out premiere. Richard Dreyfuss would be in attendance. As the owner walked out of the projection room that night, he saw Marguerite just outside the door. He was stunned, and a rush of cold air overcame him once again. She just stood there, staring, and he stared back. Then she just walked away. The owner locked the projection room door, locked the theater and went home.

When he arrived at the theater the next morning, he went to the projection room. There was no cold spot this time, and the door was still securely locked, but when he entered, he was shocked to find that the film had been

cut up into shreds. Pieces of film were all over the floor. Nothing else seemed out of place or disturbed. Everyone was then in a mad rush to get another copy of the film before the premiere. Fortunately, they found one and the premiere went on as planned, but that owner will never forget Marguerite, and he continues to tell the tale to anyone who will listen, just as the owner before him tells the tale of seeing her walk out of the elevator.

The first owner who saw Marguerite in the elevator told of one other incident that happened in the upstairs bar. He had hired a young woman to bartend, and she came in early one day to set up the bar. She left abruptly, leaving her purse, her coat and some other personal items behind, and she never came in for her shift. Naturally, the owner was concerned, and he called her several times that evening. She didn't answer. When he called her the next morning, she described what happened. She said that while she was preparing the bar, she saw a knife rise out of the drawer all on its own and hurl itself against the wall across the room. She said no one was in the room with her, and she was shocked and frightened out of her wits. She ran out of the bar and theater as fast as she could. She said that she wasn't coming back. The owner asked if she would like to come and claim her things, and she said, "Keep them." She never returned.

That incident has an eerie similarity to another incident that happened twenty years later. A young woman who occasionally works at the Avalon told a story about when she was little, about six years old, and accompanied her father to the Avalon one afternoon. He was scheduled to bartend that night in the third-floor bar, and he needed to set everything up. He had to go to the first floor to get some things, and he told the girl he'd be right back and not to touch anything. She waited, and he returned a few minutes later. When he got back to the bar, he screamed at her and chastised her for getting behind the bar and playing with knives. She told him that she hadn't moved. Then she looked on the bar. There was a large knife sitting perfectly vertical, standing up on its end on the counter top. The father didn't believe that the little girl hadn't put the knife in that position until he tried to duplicate the action. No matter how hard he tried, he couldn't get the knife to stand up like that again. It seemed impossible.

Today, if you ask people who work at the Avalon if it is haunted, they will smile and sometimes they'll say yes, but sometimes they don't want to talk about it. Several of them believe that if you pay attention to the activity—talk about it or focus on it—it stirs things up and causes more paranormal activity. So they prefer to keep silent. But just about everyone will admit that the elevator rides by itself.

CHAPTER 18
THE FRENCHMAN'S OAK

There is a plantation along the Miles River that is linked to a story about two lovers who tried to find each other in this life but ending up having to connect in the next. A young lady lived on the plantation, and she would walk the vast lawn that stretched out to the Miles River and settle herself under an enormous oak tree. There she would dream of what it would be like to travel the high seas, see new lands and meet new friends. She felt trapped in her life, because though she was from a wealthy family, she was afforded no opportunities to make her own decisions. She was not allowed to go anywhere without an escort, and her father had chosen someone for her to marry whom she did not love.

What she didn't know was that someone was watching her. A Frenchman who served in Lafayette's army was on a boat traveling up the Miles River when he spotted her there under the tree. He looked at her through the spyglass and declared to himself that he had never seen such a beautiful woman. He fell in love—just that quickly—and he knew he'd never love another woman like he loved her. He had to find a way to meet her. He got a hold of a small boat, rowed out to the plantation and found his way to that old oak tree. It was hollow and big enough for him to get inside. So he waited there for her. When the Frenchman emerged and they finally met, the young woman gave him her heart, right there under the old oak tree. He deserted his post so that he could court her. He spent many days and nights in that hollow tree and she would bring him food and they would dream about someday getting married and traveling the high seas.

Perry Hall, home of Senator William Perry. He buried his money on the property and then died. He told no one where it was.

But sadly, the young woman's fiancé discovered the tryst. He saw her walking down to the water's edge by herself, and then he saw the Frenchman emerge from the hollow oak. He watched them all night and grew angrier by the hour. He could see that they were in love, but he was not willing to let his fiancée go, even if she did love another. So he waited for a few days until he saw the Frenchman sneaking back into the hollow oak where he'd wait for his lady to come join him. But the jealous fiancé got to the oak before the young woman. He came forward with his sword and thrust it into the Frenchman just as the woman was nearing the oak. As her lover lay dying, she promised him that she would never love another and would see him again in the next life. She was inconsolable without him and spurned her fiancé's attentions. She soon died of a broken heart.

People saw apparitions of the Frenchman and his lady walking by what was called the "Frenchman's Oak" for many years. And though the oak is long gone now, there is a new tree in its place and watermen, fishermen and pleasure boaters who pass by Perry Hall at dusk or under a full moon can sometimes catch a glimpse of these two lovers standing under the oak.

Senator William Perry II married Elizabeth Hindman, whose family owned that plantation on the Miles River. William moved into the property in 1790 and began to enlarge it and expand the plantation,

making it into one of the most prominent properties on the Eastern Shore in the late eighteenth century. Eventually, William Perry became the president of the Maryland Senate, and he named this manor house Perry Hall. It still stands today on the Miles River in a part of Talbot County known as Kirkham, and it has active spirits.

In the early 1700s, when the Hindmans (Mrs. Perry's family) still owned the property, a strange event occurred—so strange that its story has survived nearly 150 years of oral tradition. Sisters Polly and Sally Hindman lived in the house. A violent thunderstorm rolled in off of the river. Polly saw a servant on the lawn and raised a window on the second floor to call the servant inside. Lightning struck, hitting Polly and coming through the window to the grandfather clock against the wall. The electric shock caused the door of the clock to swing open and gold pieces came pouring out onto the floor. There is no account about whether Polly survived.

William Perry II loved his wealth and was a shrewd businessman. Local lore states that he kept his money in metal boxes in a closet on the second floor of Perry Hall, but when Senate was in session, he would bury the boxes on his property to keep the money safe. In 1799, after burying his treasure on the Perry Hall grounds, he headed for Annapolis. Unfortunately, he died suddenly of food poisoning while he was in Annapolis, and no one knew where all his assets were buried. The fortune was never found. Eventually, the estate fell into disrepair and burned. Over the years, various people have looked for it. Treasure hunters have dug over one hundred holes on the property, and dowsers have come in with divining rods. The family even hired a clairvoyant from Baltimore, but no one has ever located any of the Perry money.

Maria "Missie" Perry Rogers was one of William Perry's descendants, and she is credited with developing the house into one of the wealthiest and most celebrated properties on the Miles River. The workings of the plantation were extensive, and Perry Hall is said to have had over one hundred slaves. But the slaves at Perry Hall weren't just field workers. They were artisans and highly skilled craftsmen producing woven fabrics, fine furniture and even Perry Hall's own brand of rose water. The plantation under Missie Rogers was famous for its garden parties, dances and other celebrations, most of which occurred on the Perry Hall grounds. A slave known as "Old Ned" or "Uncle Ned" provided music for these dances by playing his fiddle. Old Ned was so talented on the fiddle that he played for many of the parties in the region. He was a mainstay at Perry Hall.

William Perry won five-year-old Ned in a card game with Colonel Edward Lloyd of the neighboring Wye Plantation, and Ned stayed at Perry Hall until he died at a very old age. Since his death, people still see Old Ned. Most associated with Perry Hall believe Old Ned never left, and there are people who believe that Missie Rogers is still around, walking the gardens and arranging things in the house. Missie and Ned were legendary at Perry Hall. There are also stories of Missie celebrating with the slaves, bringing them refreshments down from the house.

Portrait of Missie Rogers that hangs in Perry Hall. Her spirit is believed to haunt the house.

Missie was so loved by the slaves that they composed a song for her funeral. Ned played and the others sang.

> *Old Missy Rogers died of late*
> *Straight she went to Heaven's gate,*
> *Where Old Nick met her with a maul*
> *And knocked her back to Perry Hall.*

The house stayed with Missie's descendants through the 1950s and went through a series of fires and rebuilds over two hundred years. In 1971, the Calhoon MEBA Engineering School in Easton purchased Perry Hall and its dependent properties. MEBA spent over $1 million to restore the house, and it now serves as a guesthouse and conference facility. However, MEBA has had a difficult time getting people to stay overnight and an even more difficult time getting staff to do the housekeeping. Since the renovations have been done, people have reported walking into cold spots, feeling cold rushes of air, having the lights dim and hearing voices, footsteps and loud noises—all unexplained. Lennie Martin, who did extensive research on the history of Perry Hall, states,

The Haunted Mid-Shore

Throughout its various transitions and transformations, one spirit from the Perry/Rogers era refused to leave the property—it was the ghost of Old Ned. Almost without exception, conversations with past residents, neighbors, visitors, and articles/clippings gathered during research always describe some type of friendly encounter with Ned. This holds true even today. A cold draft, an imprint on the bed cover recently smoothed, strange noises, lights mysteriously adjusted, doors opening and closing—these events are regularly reported by Perry Hall guests, housekeeping and maintenance employees.

One upstairs bedroom has had repeated sightings and unexplained events. The cleaning staff reported that after they make up the beds and smooth out the bedding, they'll return to the room to find the bedding rumpled as if someone had sat on the bed. In one instance, the cleaning staff noted a handprint in the bed coverings. Additionally, they were having trouble getting guests to stay for more than one night. No explanation was given. They guests would simply leave. I had the opportunity to interview a contractor who had installed the Wi-Fi in the house. While he was in that "active" upstairs bedroom installing the necessary equipment in the closet, he heard someone come in the front door and then call out to him. Then he heard someone ascend the stairs, but no one ever appeared. The contractor looked all through the house and then outside to see if he could find whomever was calling him. There was no one. He even asked a Perry Hall employee about it. The employee said that he'd been working near the house for over an hour and had seen no one come down the lane either by car or by foot.

Chuck Eser, who directs the MEBA complex, which includes Perry Hall, says that both the local community and the staff know that Perry Hall is haunted, and they believe that the spirits are those of Missie Rogers and Old Ned. According to Chuck, everyone just co-exists.

I would welcome the opportunity to stay there for a weekend. I'll never forget the private tour Chuck Eser provided when I was doing research for this book. I had just a few minutes in that upstairs bedroom that is said to be haunted by the spirit of Missie Rogers. Looking out over the Miles River, it's easy to imagine the thunderstorm and the lightning that may have flashed into this room and struck Polly Hindman and the grandfather clock. It's also easy to imagine the garden parties and the dancing as well as the Frenchman and his lady. There is air about Perry Hall—it's a peaceful one, but one full of memories that don't fade. The last thing I saw before we left the property

was the Perry Hall burial ground. It's situated not too far from the house in a clearing that is bordered by a fence. I couldn't help but think that so many stories are buried there.

Chapter 19

The Witches of Plain Dealing

When most people think of witches, they think about Salem, Massachusetts, and the witch trials and executions that happened there. Salem had a strong Puritan culture, and the witch accusations and trials that took place between 1692 and 1693 occurred because there was a strict intolerance for anything that deviated from the practices of the church. Eighteen people were hanged—most of them women—and one man was pressed to death. But these persecutions ended because the church hierarchy intervened and basically told the Salem community to stop that foolishness.

Witchcraft was illegal in the Maryland colony, and it was considered a felony punishable by death. But there were only a handful who ever went to trial for the offense, and of that handful, two were from Talbot County—the only Eastern Shore county to send a suspected witch to trial. And of those two suspected witches, both practiced in the same place—seventy-five years apart. They were not related and had no common bond. They lived on Plain Dealing Creek, and they became known as the "witches of Plain Dealing."

The Indians named Plain Dealing Creek after a Quaker trading post. The Quakers were called "plain" people, and the trading post was where one dealt with the plain people. This name is repeated at other locations on the Eastern Shore where Quakers traded. Today, the land around the creek is all privately owned. But it is a mystical setting. There are old hardwood trees bordering the creek and an amazing light that shifts and changes differently than in the neighboring villages. From Oxford, one can look directly across

The shores of Plain Dealing Creek.

the Tred Avon River and see the mouth of Plain Dealing Creek. It winds parallel to Tar Creek moving up toward Royal Oak.

In 1715, Virtue Violl was arrested where she lived as a spinster along Plain Dealing Creek. The charge was suspicion of witchcraft. She had allegedly rendered Mrs. Elinor Moor speechless with her diabolical practices. Maryland attorney general William Bladen indicted her for exercising black magic. Virtue was transported by boat to Annapolis, as trials were held there. The jury found her not guilty, and she went back to Plain Dealing Creek.

Forty-five years later, Samuel Chamberlain built a house on Plain Dealing Creek that later assumed the name of the creek and became known simply as "Plain Dealing." He was a wealthy tobacco grower, and he was the first Chamberlain to establish a home in America. In his later years, Samuel allowed a woman to live on the end of his property in a worn-down old shack. Her name was Katie Colburn, and she was later referred to as "Witch Katie." She terrified the local citizens and was said to be the "last of her kind" in Talbot County. Folks said that she was "old, deformed and hideous…and one whom no one would look at for fear of being hoodood by a wicked glance from her evil eye." Katie was the second witch to practice on Plain Dealing Creek, seventy-five years after Virtue Violl.

No one knows what happened to either of the witches. Katie just disappeared. But a ghost is said to have appeared to some of the Valliant children who lived on the Plain Dealing property many years later. Some say Katie was trying to send a message into the living world about the horrible Valliant murder in which one brother killed the other over found treasure. Sightings of Witch Katie around Plain Dealing Creek were reported into the twentieth century. Witnesses would describe her as a tiny, hunched-over woman with wild hair. She was most often seen in the woods.

The Valliant brothers lived on the haunted Plain Dealing waterway. There are several versions of the Valliant brothers' story, but we do have actual commentary from Lloyd Nicols Valliant, son of Jeremiah Valliant, who was a tenant farmer on the Chamberlain property in the mid-nineteenth century. Lloyd stated that when he was a boy of ten years old, he saw a man standing near the Chamberlain graves on the Plain Dealing property. The man was pointing to an impression in the ground. Lloyd was frightened and ran to his mother. She walked back to the area of the sighting with her son, and the man was still standing there. The mother couldn't see him, but Lloyd could. He described the man as older with long white hair. The man was wearing breeches instead of trousers.

Lloyd and his mother came back again several times, and each time, Lloyd could see the ghost, but his mother couldn't. The last time Lloyd saw the ghost he was by himself and had the courage to approach the spectral figure. The ghostly man led young Lloyd inside the old Plain Dealing mansion, long vacant and full of dust and mold. Old portraits of the Chamberlain family still hung on the walls. The man pointed to one particular portrait. It was the portrait of Squire Ungle, a man who had fallen to his death from the balustrade above when he was drunk one night. He broke his neck, and legendary stains from his blood still marred the Plain Dealing floor and were much talked about by family members. Lloyd recognized the ghostly man as the same man in the portrait. He was Squire Ungle.

Young Lloyd and the ghost walked again to the Chamberlain family cemetery, and this time the ghost spoke. He pointed to the depression in the ground and said that there was treasure buried there beneath some stones as far down as a well. It was left there by one of the Valliant brothers from many years ago. One Valliant brother dreamed that there was treasure buried in this exact spot. He shared his dream with his brother, and together they dug a hole ten feet deep and came upon a chest made of oak. They pulled the chest out and opened it. It was full of gold—enough gold to make them both rich. Suddenly, the brother who had the dream lost his mind and lunged at

the other brother. He killed him in order to have the treasure all to himself. But upon looking at the lifeless body of his brother, the dreamer was filled with such remorse that he reburied the treasure and placed the corpse of his beloved brother in the hole with the treasure and closed the grave—telling no one.

After hearing this tale from the ghost of Squire Unger, young Lloyd Nicols Valliant ran to his father and recounted the story. The father, with the help of some Negro slaves, dug a hole ten feet deep in the identified location and came upon stones. Lloyd Nicols Valliant said that when they uncovered the stones, there was no treasure. But shortly after the failed treasure hunt, Lloyd's father bought Sharpe's Island, which would have cost a much heftier sum than most tenant farmers could afford.

So what of the witches of Plain Dealing and the Valliant brothers and Squire Ungle coming back from the dead? These stories span over two hundred years, and still people claim to see Witch Katie. What is it about Plain Dealing that keeps the spirits active?

CHAPTER 20

THE UNIONVILLE SOLDIERS

The little village called Unionville between Easton and St. Michaels is not haunted, but it represents a wonderful tale of the dead. Unionville is linked to a touching Civil War story involving eighteen ex-slaves and free blacks who fought for the Union army between 1863 and 1866.

We can all grasp the cruelty and injustice of slavery, but what most people don't know is that the black communities had horrible struggles after the war—some were worse than being enslaved. Almost no one welcomed the influx of blacks into the communities. They wouldn't let black children in the schools. Blacks were barred from having businesses in some places. There was also a fear that the blacks might band together and retaliate against the white communities who had enslaved them, and this fear fueled ridicule and a desire to ostracize blacks and drive them from white communities. So many blacks who had beat the odds and survived the battlefields in the Civil War faced a new war once they were discharged.

But in spite of the collective unwelcome toward blacks after the war, one Quaker family from Talbot County decided to slice out a portion of their plantation to develop a community for eighteen black Talbot County residents who had fought with the U.S. Colored Troops. When the eighteen blacks were discharged in 1866, Ezekiel and John Cowgill—Quakers who owned Lombardy Plantation in Talbot County—carved out a parcel of land for these soldiers. They offered each of them a plot of land where they could have a house and a vegetable garden for one dollar a year. All eighteen settled there and built a community, starting with a church and a school.

Easton and Surrounds

Grave markers from two U.S. Colored Troops who were part of a group of eighteen U.S. Colored Troops veterans who settled Unionville.

They named it Cowgilltown after their benefactors. The community grew from the descendants of these eighteen men, and it still exists today.

The community later renamed their town "Unionville" after the common thread that stitched the founding inhabitants together. They all fought for the their freedom in the Union army. Each one of the original eighteen soldiers are buried behind the church they founded, St. Stephens AME Church. Their graves are well looked after, each decorated with a small American flag. The graveyard now has many graves, most being the descendants of those original eighteen. It is a tribute not only for these eighteen colored troops who managed to survive the war and the postwar period but also to the Cowgills, who made it possible by sharing land and offering a warm welcome.

Part V
St. Michaels

St. Michaels began as a community back in the 1600s when there was a trading post here for tobacco farmers and trappers. The town still reflects that colonial era as some of the buildings date back to the 1700s and early 1800s. It's probably best known as the town that fooled the British. During the War of 1812, the residents of St. Michaels were warned that the British were poised for an attack on the town. So the town hatched a plan to get lanterns and climb up in the trees and hold the lanterns as high as possible. The British would think that those lantern lights were the lights of the town. When the British fired on the town, they overshot it and their cannonballs went higher than the buildings. All of the buildings were spared except one, which is now known as the Cannonball House because a cannon ball hit its roof, fell through its attic, rolled down the hallway and staircase and right out the front door. The house still has the old cannon ball.

St. Michaels got its name for Michaelmas day, which is September 29, the day the rents were due to Lord Baltimore. The town started as a trading post, grew into a village and kept growing until it was a town recognized for being a hub for shipbuilding. This drew in sailors, shipbuilders and transient people who made St. Michaels a stop on a trade route. The town had some pretty bawdy characters and everything else that goes with a sailors' town—liquor, fighting, gambling, loose women. There were also farmers and watermen, slaves, free blacks and merchants. St. Michaels had a very famous slave named Frederick Douglass. His name was originally Fred Bailey. Because he was stubborn, Fred was sent to a slave breaker named

The Haunted Mid-Shore

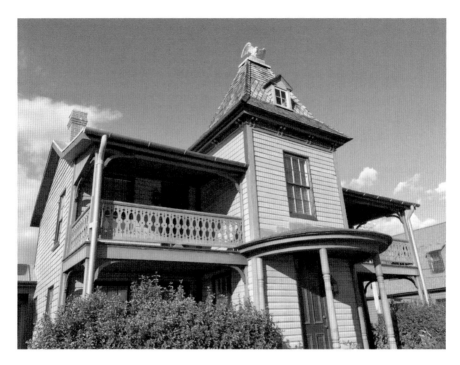

The Eagle House once belonged to a steamboat captain, and the golden eagle on top was once a steamboat ornament.

Edward Covey. Douglass stood up to Edward Covey, which gave him a kind of self-confidence that he tried to bring to other enslaved people. Later he became a great political leader.

After the Civil War, the days of the big plantation owners who had many slaves to work the plantation came to an end. And big farms were carved up and divided into parcels that were sold off to pay debts. The economy became more diversified. But in the early 1800s, the steamship or steamboats opened up tourism on the Eastern Shore. And St. Michaels responded beautifully.

If Ocean City and the Atlantic beaches are what draw most of the visitors across the Bay Bridge and on down Route 50, St. Michaels is the second biggest draw. Everyone knows Ocean City, but if you ask visitors what else is on the Eastern Shore, they will likely say "St. Michaels."

CHAPTER 21
The Spirits of Navy Point

Besides being known as the town that fooled the British, St. Michaels is also known for its harbor and connection with boats and maritime history. There is a spit of land that juts out into the harbor just east of the historic downtown. A purser named Samuel Hambleton purchased this land in 1814 and named it Navy Point. Hambleton loved naval history and culture, and he divided the property, naming three of its streets in honor of navy admirals. At one time, Navy Point was a center of trade, with storehouses, shipbuilding and ship repair facilities, a steamboat landing and a seafood-processing plant. Today, it holds the Chesapeake Bay Maritime Museum, which includes a complex of historic buildings.

One of those buildings serves as the Visitor's Center and museum store. It looks like a house, and it is white with five windows across the top. The house is not standing in its original location. It was moved by the Chesapeake Bay Maritime Museum, but the museum staff says that its original location is not far from where it sits now. According to several museum staffers and volunteers, this house is haunted. The second floor is used for storage, and museum store staff say that things fall off the shelves up there—but not in a normal way. Things that were securely stored on shelves will end up strewn on the floor as if someone picked them up and threw them across the floor. There's no sense to it. They've also heard what sounds like footsteps and activity on the second floor, but when someone investigates, there's no one there.

When I inquired about the house's history, there were several answers, but none were definitive. The common belief is that it was a brothel. This

The Haunted Mid-Shore

CBMM Center Museum Store at the Chesapeake Bay Maritime Museum. Some think it was once a brothel.

is because the rooms on the second floor are very tiny. They're barely wide enough for a bed, and above the doors, there were numbers labeling each room. Another confirmation was that interns that came to the Maritime Museum to work were once housed in this building, but several of them were tormented in the night and couldn't get to sleep. Something kept tickling their feet or trying to get in bed with them. The chief curator said there's no proof that it was ever a brothel, but he did confirm that it was a common belief and that there is no proof that it wasn't.

The Eagle House is another allegedly haunted property on Navy Point. It was built by the well-known Dodson family and is a reminder of how the tourism industry grew in St. Michaels. It was the home of a steamboat captain. The steamboats would come into the harbor twice a week from Baltimore, bringing tourists and visitors to St. Michaels. Eventually, that cluster of tourists swelled, the merchants expanded their offers to tourists and the town grew to become the great travel destination it is today. The tourism initiative all started with tourists who came in on the steamboats.

Today, the Eagle House houses the steamboat collection owned by the Chesapeake Bay Maritime Museum. The golden eagle on top of the

St. Michaels

building came from a steamboat, and the building takes its name from that eagle.

Staff members in the Eagle House say that they sometimes hear conversations between men in the main room of the Eagle House. When this happened, they think tourists may have wandered back there. But no one can access that room without walking right past the reception area. The outside entrance to that room is sealed. When the staff members hear the conversation, they investigate but never find anyone present. Sometimes the conversation is between two men, and sometimes it's between a man and a child. One of the staff members said she actually saw a little boy in a sailor-type outfit run into that same front room. But he never came out, and when the staff went to look for him, he was gone.

CHAPTER 22
PENNIES FROM HEAVEN

One of the most beautiful homes in St. Michaels sits at the east end of Cherry Street on an expansive lot that overlooks Navy Point and the St. Michaels Harbor. Its stunning mansard roof decorated with tiles makes it stand out among all the other houses that border the harbor. It was built by Henry Clay Dodson around 1875 and later purchased by Norman Shannahan, and in its lifetime, it has borne the name of both of these men. But today it's known as Aida's Victoriana Inn, and its gracious owner shared a beautiful story about one of her guests who never checked out.

It was a single man, trying to get away from the stresses of his life. He was married but evidently was suffering from depression. He looked forward to getting away for the weekend, and he booked a room at the Victoriana Inn. When he arrived he met with Aida, the innkeeper. He offered to pay his bill in full at check-in, but Aida told him that wasn't necessary. Guests pay when they leave. He could check out then.

Early the next morning, the man's wife called Aida asking her to check on the man. It was so early that Aida was reluctant to do so, fearing that the man might get angry being disturbed so early when he was on vacation. But the wife was persuasive, and Aida knocked loudly on the man's door. He didn't answer. She knocked louder and called out to him. He still didn't come to the door. The wife was still on the phone, and she begged Aida to unlock the door. Aida was hesitant, not wanting to intrude on the man's privacy, but she did unlock the door and stick her head in.

St. Michaels

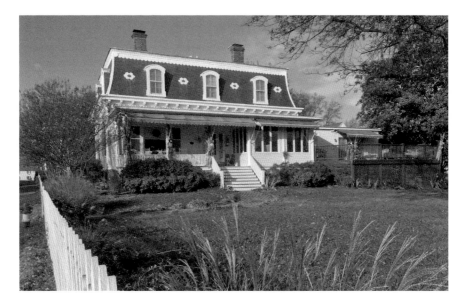

Victoriana Inn in St. Michaels. The spirit there is still trying to pay his bill.

He was on the bed. Aida also works as a flight attendant, which requires her to be CPR certified. She immediately saw that he was in trouble. He was gray. She pulled him off the bed onto the floor and started administering CPR. But it was too late. The man had already died. During my interview with Aida, she said more than once, "He was so young."

After the body was removed, Aida gutted the room. She got rid of the furniture, linens and window coverings. She had the walls painted and the wood floors refinished. She was due to travel for her job and expected to be gone for about three weeks. Just before she left, she inspected the room where the young man had passed away. The furniture was gone, the paint was fresh and the floors refinished. It was a brand-new empty shell. The new furniture would arrive once she returned. Aida left the room, closed the door and locked up the house for three weeks. When she returned and reopened the inn, she entered that room again to inspect it before the new furniture was to arrive. She found three pennies on the hardwood floor. They weren't there when she had left. No one had access to the house in her absence either. It was strange.

A little while later, Aida found some pennies on the floor in the dining room. When the furniture arrived a few days later, Aida led the movers into the room and again noticed three pennies on the floor. That weekend, she

was sitting at the kitchen table with a woman whom she hired to do some cooking for her guests. Aida told the woman about the pennies. As they were talking, three pennies rolled off the table onto the floor and landed right on the spot where that young man had stood when he checked in and tried to pay his bill. The cook said, "These are pennies from heaven. That man is trying to show you that he is sorry that he never paid his bill."

Pennies keep coming. Aida has been finding them throughout the house for years now. She keeps them in a kitchen drawer. The drawer was half full when I saw it in back in 2013. It must have hundreds of pennies by now.

CHAPTER 23
THE KEMP HOUSE AND ROBERT E. LEE

The white Georgian home, known as the Kemp House, on the corner of Talbot and Tilden Streets in St. Michaels doesn't look haunted. With so many historic houses on that main street, it doesn't even stand out. Currently, the Kemp House is an inn that is owned by the same people who own the Old Brick Inn. The staff members who clean the house and take care of the guests have stories to tell. They affectionately call the ghost who haunts the Kemp House "Joseph" after Colonel Joseph Kemp, the Revolutionary War soldier and hero of the War of 1812. He built the house in 1805. Sometimes Joseph manifests himself as a blue streak. He's been seen in that form coming through the front door and heading up the staircase.

But Joseph Kemp isn't the only spirit haunting the Kemp House. There are others, but all appear to be men. One of the spirits is believed to be Robert E. Lee, who spent a few nights at the Kemp House when he was visiting his friends who were descendants of Joseph Kemp. Evidently, General Lee is one of the men heard talking outside the blue room, and others have seen him. It seems the blue room—a guest room on the second floor—is a favorite spot for the general. The owner of the Kemp House believes Robert E. Lee's spirit comes and goes at the Kemp House, and she indicated that while it was a peaceful house with a warm energy, it has its share of ghosts.

Over the years, guests who have stayed in the blue room reported someone being in the room with them. A couple that was staying in the blue room said that the wife woke up and had the feeling someone else was in the room.

Kemp House Inn in St. Michaels is believed to be haunted by the spirit of Robert E. Lee.

She stood up and walked through the room. When she saw there was no one there, she figured that she must have had some kind of dream that made her feel that way. She got back into bed and happened to glance over at the rocking chair. It was rocking on its own.

A family staying at the Kemp House reported another incident. The father and son stayed in the blue room with the father sleeping in the double bed and the son sleeping in the trundle bed. The father felt someone get in the bed with him, feeling the mattress beside him sink down and hearing the sliding of a body on the sheets. He assumed it was his son. But he glanced over at the trundle bed and saw his son there. Startled, he jumped out of bed to look at who else was in the room. There was no one. The other side of the bed was still made up, showing that no one had actually disturbed the sheets or bedspread on that side.

The majority of people that stay in the blue room never have any kind of paranormal experience. But when there is an experience upstairs, it's usually in the blue room. Employees working alone in the building hear the blue room door slamming shut. They're used to it now and figure it's either the spirit of Joseph Kemp or the spirit of Robert E. Lee.

One other incident with housekeeping occurred in the blue room with a new housekeeping staff member who had only been on the job for three

days. She was cleaning the bathroom when she heard a number of voices very clearly outside the door of the blue room. They were both men and women in general conversation. There also seemed to be the sound of a harpsichord in the background. She stepped out of the bathroom thinking a party had emerged while she was cleaning. But there was no one there at all. The music and voices stopped as soon as she opened the door. Since she was new, she wasn't familiar with the sounds and rhythms of the house. She thought it might be sound carrying from somewhere else. She checked for an intercom speaker or perhaps a heating or cooling duct that might have been carrying a sound. There was none.

She began cleaning again, and the voices and music returned. It sounded like these people were having a good time. There was laughing and conversation. She opened the door, and again, all the sounds of conversation and music vanished. She was a bit unsettled and left that room and went on to another upstairs room. When she had finished there, she returned to the blue room to retrieve her plastic cleaning pan. Stepping into the bathroom, she waited for the voices and never took her hand off the door. As soon as she heard the voices, she threw open the door quickly to see if she could catch someone. There was no one there.

Another housekeeper had a similar situation, but it was on the first floor. She was in the house alone. There were no bookings or guest scheduled to arrive. She was doing the laundry, changing the sheets and doing general housekeeping. She crossed the hall and walked toward the office. Out of the corner of her eye, she saw and heard two gentlemen enter the front door and immediately step into a room on the right. There were no guests expected, so she moved quickly down the hall to that room and stopped at the closed door, where she distinctly heard them talking. She tapped on the closed door and stepped into the room. But the room was vacant. There was no one there. She was puzzled and backed out of the room, closing the door behind her. She figured she'd made a mistake. Seconds later, she heard the voices again, and she burst back into the room. She thought maybe they had stepped into the bathroom out of her sight so she searched the area thoroughly. There was no one there. She went to her small office and called over to the Old Brick Inn, which was where guests checked in. She asked if they had sent the two gentlemen down, and they said that they'd had no check-ins or inquiries and had not directed anyone to go down to the Kemp House.

Two women who stayed at the Kemp House over Christmas reported another mysterious experience. They were the only guests checked in, and

the only two people in the house—so they thought. They exchanged gifts in their room on Christmas Eve and then cleaned up the area, throwing all the used wrapping paper in the trash. When they returned to the house a few hours later, they found all the wrapping paper on the floor again.

Our ghost walk goes past the Kemp House, and in the summer there are always happy guests sitting out on the porch. Most of them claim that they see no ghosts and have no haunted experiences. But the staff readily admits that the spirits make themselves known.

Part VI
Oxford

Oxford is a colonial port town that has retained the look of its historic streetscapes and buildings over the centuries. Situated near the mouth of the Tred Avon River, Oxford started out as a trading post and later became a bustling port town. There was a time when Oxford was the second busiest port in Maryland—second only to Baltimore—and the town was in the running to become the eastern capital of Maryland but lost out to Easton. Today, Oxford is an exclusive community that prides itself in being one of the most historically intact towns in the state. Visitors come to Oxford just to take in the streetscape and feel that "step back in time." Oxford became famous for shipbuilding and still has boatyards and

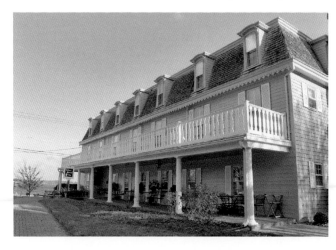

The Robert Morris Inn in Oxford sits on the Tred Avon River.

many marine trade businesses. It also has a ferry that carries vehicles and passengers across the river to Belleview. The ferry is said to be the oldest privately owned ferry in continuous operation in the United States.

History is palpable in Oxford, which brings the spirits out into the open.

CHAPTER 24

MY SCARY NIGHT AT THE ROBERT MORRIS INN

I knew the Robert Morris Inn was haunted, but I never expected to have my own ghostly experience there. Out of the 150 ghost stories I've collected and retold about spirits on the Eastern Shore, I've only had personal experiences at a handful of these sites. The Robert Morris Inn is one of those places. Named for the father of the Robert Morris who became known as the "Financier of the American Revolution," the Robert Morris associated with this inn was an Englishman who once lived there. In those days, the building was smaller.

It's the most prominent building in Oxford, with its mustard-colored clapboard siding and mansard roof with seven dormer windows across the top. It looks much the same as it did three hundred years ago except for a few air conditioner window units. The building dates back to 1710, and it's likely that it was always a tavern.

The owners of the inn shared a story with me about a guest who fled in the middle of the night. She was staying in Room 1. She left a note that said:

Room 1 Checked Out
It is TOTALLY HAUNTED. I left at 5:50 a.m. Here is what I experienced. Light next to bed turned off. Heavy man got in bed next to me. He was raging with fever. I woke up saturated in sweat. British man talking about Jenny. British man talking about the Hog Roller. Saw man lying on floor beside bed with a soldier standing over him. Then the bed began to rock violently like a roller coaster. I kept trying to yell for help but

The Haunted Mid-Shore

could not get my mouth open. Opened my eyes and saw a roach crawl up the left bed post. That was it. That room has an energy vortex. It is holding the energy from Man's death. Sorry to miss breakfast. I am out of here.

The innkeeper says that it was likely that Robert Morris died in that room. It's a large bedroom on the second floor in the corner of the house that faces the river. Robert Morris was a wealthy Englishman who represented a large Liverpool trading company in the American colonies, and Oxford was a good home base because of its busy port. The company purchased the inn in 1738, and Robert Morris lived in a portion of it. He died a strange death. He was accidentally struck by the wadding of a ship's gun that was fired in his honor. The wound festered until the infection killed him. He died at home, which was the inn now named for him.

In November 2014, I had the opportunity to stay at the Robert Morris Inn. I had a room booked for the first night of the Waterfowl Festival in Easton, and I had phoned the inn saying that I would be arriving after 9:00 p.m. The innkeeper told me that she would leave the key on the console in the lobby. The night was bitterly cold. I arrived at 9:30 p.m. and saw an envelope with my name on it and a key to room 18. I ascended the stairs and walked down the hall to my room for the night.

When I opened the door to room 18, I saw suitcases and clothes on the bed. Room 18 was occupied. I quickly shut the door and went back downstairs and asked a staff person in the restaurant for assistance with the mistaken room. She apologized and went for another key. I had a glass of wine at the bar while she straightened out the situation. After a few moments, she arrived with the key to Room 1, and I settled in, very pleased to find such a beautiful, spacious corner room with two views of the Tred Avon River.

I was still a little startled from nearly walking in on the unsuspecting guests in Room 18, so I carefully locked the door to my room and secured the old-time chain. The room was very warm, which was a nice contrast to the sound of the wind blowing across the river. I recalled the owner telling me that one of the rooms was haunted, but I couldn't remember which one. I stood in the room silently for a moment and tried to sense the energy. I felt nothing but a warm, cozy room. No weirdness. Nothing unwelcoming. It was just a very nice place to stay for the night. I worked for awhile and then went to sleep.

In the middle of the night, I woke up to what sounded like a rush of wind. I was freezing. I sat up in bed and looked around in the dark. The door was closed and both windows securely closed. I got out of bed and

checked the door. The chain was still secure. I walked over to the radiators and they were hot to the touch. But I was still freezing, feeling like I'd been in a deep sleep outside with no blankets on. The room felt strange. Why was I cold and the room warm? I got back into bed. While trying to fall asleep, I kept reimagining the sound of the wind that I heard when I woke up. I finally fell asleep.

When I got out of bed in the morning and walked to the bathroom, I saw about half a dozen dried maple leaves strewn across the floor between the bed and the bathroom door, just under the window. I gathered them up and discarded them. What a mystery that was. There were more leaves on the windowsill and more just outside the window. I lifted the window to see if it was locked (it wasn't), and all of the leaves that had collected on the sill blew into the room with the force of the heavy wind coming off the river. The leaves scattered across the floor in almost the same pattern as the ones I had just picked up and discarded.

I'll never know how those leaves got into the room. The door was still chained, and it could only be chained from the inside. The unlocked window was the most likely entry point. But how did it open on the second floor without my opening it? Before I went down for breakfast, I pulled out my laptop and looked up my notes from the conversation I'd had with the inn's owner. I saw the notations about the letter the guest left and saw that it was Room 1—the same room I was staying in.

Unlike the previous guest in Room 1, I saw no man or soldier in my room and no one was heard talking about Jenny. But there were two startling unexplained events—a raging wind blowing leaves into the room through a closed window and waking up freezing even though the radiators were kicking out massive amounts of heat. Something was in my room that night.

CHAPTER 25
THE DEATH CHANT AT BACHELOR'S POINT

On the south end of Oxford is a spit of land known as Bachelor's Point. An old legend says that if you stand on Bachelor's Point in the dead of night, quiet yourself and listen intently, you may hear the distant cries of the ancient Algonquin Indian tribe that lived and died on Bachelor's Point.

One day, the men of the Indian village went to do battle. They left their wives and children back in their village. But their enemy was superior in both numbers and weapons. The men lost the battle, and all but a few were killed. Those survivors rushed back to their families, who were left unprotected on Bachelor's Point. Their enemy pursued them, anxious to humiliate and kill them. The ones who hadn't been slain would be pressed into slavery. Now at the mercy of an onrushing foe, the Bachelor's Point Indians made a pact that they would not be taken by this enemy. They retrieved all of their heaviest war implements and tied them on to their shoulders. Then they gathered, arm-in-arm at the shoreline, and began to sing their death chant as they moved as one solid column into the Tred Avon River. They continued marching and chanting until the last brave Indian was swallowed up by the river, and the last singing voice was silenced.

On moonlit nights, residents of Bachelor's Point and fishermen in the vicinity can sometimes hear the faint sound of that death chant. It starts as a drumbeat and builds until it becomes a mournful chant that echo across the water. The final cries of the Indians at Bachelor's Point are still heard.

Afterword

Almost every entry in this book began with one snippet of a story. To go from being a snippet to being a complete story, I had to search for more snippets, find other people who had similar stories, research the history on the place and then interview people associated with the site. One thing in that process never got old, and that was the personal interviews. Whether I talked to old people, young people, come-heres, born heres, wealthy folks or poor folks, black folks or white folks, one common thread runs through every storyteller, and that is a sense of belonging to the land. This place—the Eastern Shore—about which I write has a draw, a magnetism that makes people want to come here, to return here and, when they can't physically be here, to return in their minds. This sentiment is expressed so simply in a short poem written by Frank Butler. He was a marksman in the Wild West variety shows that moved around the country in the late eighteenth century. He was married to Annie Oakley, and shortly after they retired, they built a home in Cambridge that overlooked the Choptank River. They didn't stay long—it was only few years before they moved away. But Frank penned a poem that showed that the Eastern Shore was on his mind.

> *Here I am on the Great White Way,*
> *Where night is turned into day;*
> *The awful racket of trolley and train*
> *All make me long for home again.*
> *There I watch the sun at early day*

Afterword

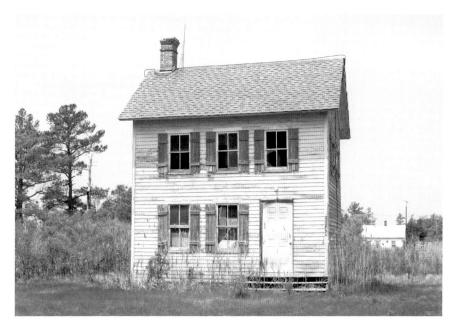

Abandoned house in lower Dorchester County.

Climbing over the river and bay,
Where the air is pure and minds are, too.
No hard times, and plenty to do.
They may have the city, with its riot and roar,
But for me its back to the Eastern Shore.
Where oysters are big and plenty, too,
You don't pay a dollar for a church fair stew;
Where girls are as pretty as any you'll find.
And, better yet, they are the right kind.
Where men are good enough, but not too good—
Where our neighbors are just Jim and Bill—
We even call our Governor Phil—
Where the latch string hangs outside each door,
A welcome awaits you on the Eastern Shore.

BIBLIOGRAPHY

Books

Byron, Gilbert. *St. Michaels, the Town That Fooled the British: A Complete Account of the British Attacks on St. Michaels During the War of 1812*. Easton, MD: Easton Publishing, 1963.

Chappelle, Helen. *The Chesapeake Book of the Dead*. Baltimore, MD: Johns Hopkins University Press, 1999.

Claggett, Laurence G. *From Pot Pie to Hell & Damnation: An Illustrated Gazetteer of Talbot County*. St. Michaels, MD: Chesapeake Bay Maritime Museum, 2004.

Cooke, William H. *Witch Trials, Legends and Lore of Maryland: Dark, Strange, and True Tales*. Annapolis, MD: Undertaker Press, 2012.

Fleetwood, Mary Anne, and Betty Carroll Callahan. *Voices from the Land: A Caroline County Memoir*. Queenstown, MD: Queen Anne Press, 1983.

Flowers, Thomas A. *Dorchester County, Maryland: A History for Young People*. Easton, MD: T.A. Flowers, 1982.

———, ed. *Souvenir Book: Dorchester Tercentenary*. Cambridge, MD: Bay Country Festival, 1969.

Harrington, Norman. *Easton Album*. Easton, MD: Historical Society of Talbot County, 1986.

Hughes, Elizabeth. *Historic St. Michaels: An Architectural History*. St. Michaels, MD: Historic St. Michaels-Bay Hundred, Publisher, 1996.

Jameson, W.C. *Buried Treasures of the Mid-Atlantic States: Legends of Island Treasure, Jewelry Caches, and Secret Tunnels*. Little Rock, AR: August House, 2000.

Lanier, Gabrielle. *The Delaware Valley in the Early Republic.* Baltimore, MD: Johns Hopkins University Press, 2004.

Paterson, Jacqueline Memory. *Tree Wisdom: A Definitive Guidebook.* London: Thorsons, 1996.

Prince, E.D. *Delaware and the Eastern Shore of Maryland and Virginia.* Wilmington, DE: John E. Harlan and the Star Publishing Company, 1926.

Reid, Donald L., Roger Guy Webster and Hubert H. Wright IV. *Cambridge, Past and Present: A Pictorial History.* Norfolk, VA: Donning, 1986.

Ridgely, Helen W. *Historic Graves of Maryland and the District of Columbia.* Baltimore, MD: Genealogical Publishing, 1967.

Roth, Hal. *You Still Can't Get to Puckum.* Vienna, MD: Nanticoke Books, 2000.

Stump, Brice. *It Happened in Dorchester.* 1st ed. Easton, MD: Economy Printing, 1969.

Tilghman, Oswald, and S.A. Harrison. *History of Talbot County, Maryland, 1661–1861, Compiled Principally from the Literary Relics of the Late Samuel Alexander Harrison.* Baltimore, MD: Regional Publishing, 1967.

Weeks, Christopher, and Michael O. Bourne. *Where Land and Water Intertwine: An Architectural History of Talbot County, Maryland.* Baltimore, MD: Johns Hopkins University Press, 1984.

Weeks, Christopher. *Between the Nanticoke and the Choptank: An Architectural History of Dorchester County, Maryland.* Baltimore, MD: Johns Hopkins University Press, 1984.

Articles and Pamphlets

Ames, Joseph S. "The Haskins and Caile Families of Dorchester County." *Maryland Historical Magazine* 40 (March 1916).

Baltimore Sun. "Ghosts, Witches and 'Ha'nts' of the Eastern Shore." October 13, 1912.

Cambridge (MD) Chronicle. "Most Horrible Crime." February 1831.

Cambridge (MD) Democrat and News. "Execution of Bloody Henny." July 18, 1908.

Chicago Tribune. "Police Hunt Woman Court Blast Suspect." March 12, 1970.

Folklore Collection Files. Edward H. Nabb Research Center at Salisbury University, 1975.

Martin, Lennie. "A History of Perry Hall." June 18, 1996. Available at the Talbot County Free Library.

Weinberg, Albert E. "Eastern Shore Rich in Folklore." *Baltimore Sun,* June 17, 1928.

Bibliography

"Woodland Ferry: Crossing the Nanticoke from 1740s to the Present." *Archaeological Research Report*, Hunter Research, Inc. Delaware Department of Transportation.

Multimedia

"The LeComptes of Castlehaven: Lecompte Family Stories: Fact & Fiction." Website detailing genealogy, folklore and history of the LeCompte families descended from Antoine LeCompte. www.lecompte.net.

Personal Interviews

Aida Trissell, owner of the Victoriana Inn, St. Michaels, MD.
Charles Moore, Moore Funeral Home, Denton, MD.
Chuck Eser, director of the Calhoun MEBA Engineering School, Easton, MD.
Ian Fleming, owner of Robert Morris Inn, Oxford, MD.
John General, former co-owner of the Avalon Theater, Easton, MD.
J.O.K. Walsh and members of the Caroline County Historical Society.
Marilyn Griffies, owner of Cannon Hall.
Pete Lesher, curator, and staff at the Chesapeake Bay Maritime Museum.
Ruth A. Colbourne, superintendent, and staff, Caroline County Detention Center, Denton, MD.
Volunteers at the Richardson Maritime Museum.
Will Howard, former owner of the Avalon Theater, Easton, MD.

About the Author

Mindie Burgoyne became interested in ghost stories when she and her husband, Dan, moved into a haunted house in Somerset County, Maryland, in 2002. She began collecting ghost stories about the haunted Eastern Shore and eventually wrote *Haunted Eastern Shore: Ghostly Tales from East of the Chesapeake*, a book published by The History Press in 2009. Her readers began inquiring about ghost tours to some of the places in her book, so she organized a few bus tours and continued to collect ghost stories. In the course of five years, she has collected over 130 ghost stories and designed ten ghost walks in towns across the Delmarva Peninsula. In 2014, she and her husband founded Chesapeake Ghost Walks. They hired and trained ghost tour guides and began a campaign to market a ghost walk trail that runs from Easton to Ocean City.

With ghost tour guests asking for more written stories to have as a memento of their ghost tours, Mindie began writing a three-book haunted trilogy on the Eastern Shore in the areas that cover the ghost walks. In October 2014, The History Press published the first book in that series, *Haunted Ocean City and Berlin*. This book, *The Haunted Mid-Shore*, is the second book in the series. Mindie continues to roam the Delmarva Peninsula, scouting out new haunted locations and interviewing the locals about ghosts, spirits and folklore.

Chesapeake Ghost Walks is a subsidiary of Travel Hag Tours, the Burgoynes' travel company. Under this brand, they offer custom tours designed for those who want a travel experience that feeds the mind, body

About the Author

and spirit. They offer tours every year to Ireland's mystical places and sponsor a travel club for girlfriends in the United States.

By day, Mindie works full time for the State of Maryland doing rural economic development, assisting Eastern Shore businesses and local governments by connecting them with resources that will help grow the economy. Additionally, she is on the board of directors for the Edward H. Nabb Research Center at Salisbury University.

Mindie and Dan Burgoyne have six children and ten grandchildren. They love the outdoors and spend most of their free time traveling. She writes from their home in Marion Station, Maryland.